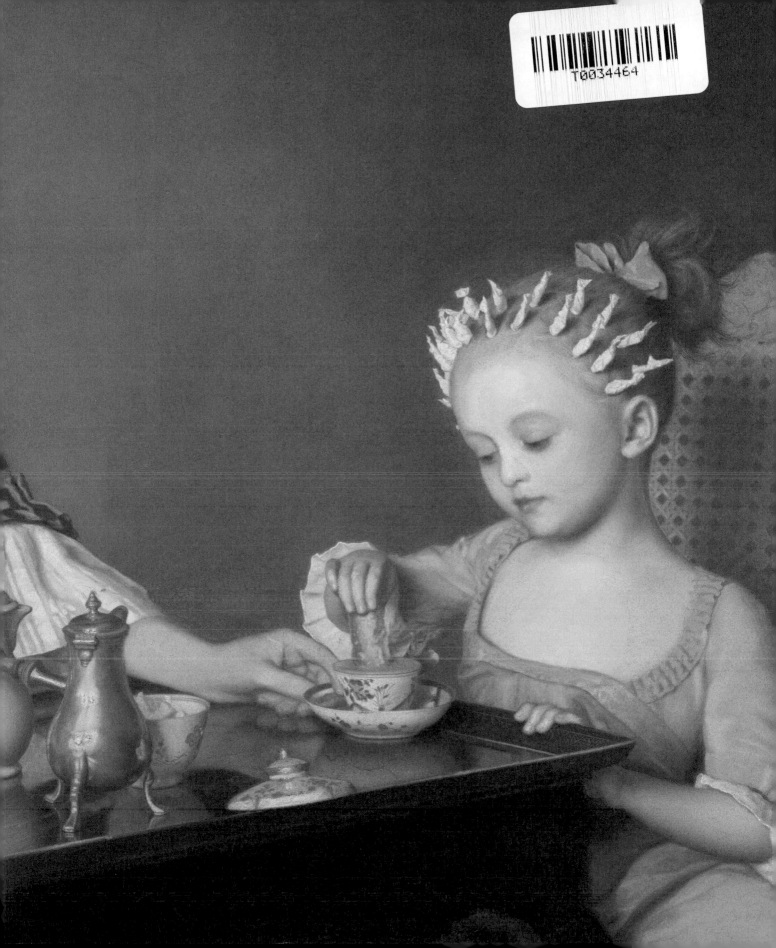

DISCOVER LIOTARD & THE LAVERGNE FAMILY BREAKFAST

FRANCESCA WHITLUM-COOPER
WITH A CONTRIBUTION BY IRIS MOON

NATIONAL GALLERY GLOBAL, LONDON
DISTRIBUTED BY YALE UNIVERSITY PRESS

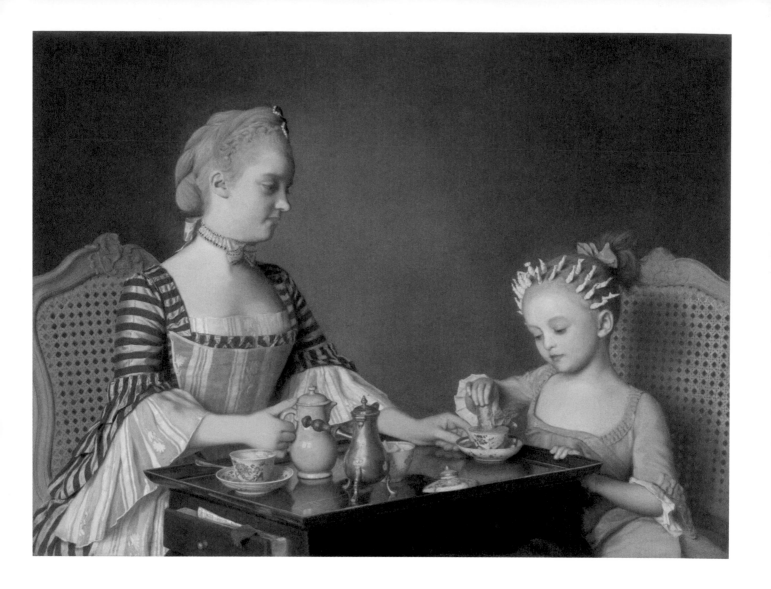

Introducing *The Lavergne Family Breakfast*

In 1754, Jean-Etienne Liotard (1702–1789) painted his pastel masterpiece, *The Lavergne Family Breakfast*. He sold the picture to his most important patron, William Ponsonby, later 2nd Earl of Bessborough (1704–1793), for the very high price of 200 guineas. He did not see it again for almost twenty years.

In 1773, Liotard returned to *The Lavergne Family Breakfast* and made an exact replica in oil. As far as we know, no one has seen these two works together since Liotard and Bessborough viewed them side by side in 1773. The two works are reunited at the National Gallery for the first time in 250 years. The exhibition and accompanying catalogue allow us to stand in their shoes, to look closely at the differences between the pastel and oil mediums, and to explore Liotard's greatest composition.

Fig. 1
The Lavergne Family Breakfast,
1754
Pastel on paper, mounted on
canvas, 80 × 106 cm
The National Gallery, London

Fig. 2
The Lavergne Family Breakfast,
1773
Oil on canvas, 81.4 × 103 cm
Private collection, Waddesdon

Published to accompany the exhibition:

Discover Liotard & The Lavergne Family Breakfast
The National Gallery, London
16 November 2023–3 March 2024

Exhibition supported by

The Thompson Family Charitable Trust

Katrin Henkel
And other donors

The Sunley Room exhibition programme is
supported by the Bernard Sunley Foundation

This exhibition has been made possible
by the provision of insurance through
the Government Indemnity Scheme.
The National Gallery would like to thank
HM Government for providing Government
Indemnity and the Department for Culture,
Media and Sport and Arts Council England
for arranging the indemnity.

First published in 2023 by
National Gallery Global Limited
Trafalgar Square
London WC2N 5DN
www.shop.nationalgallery.org.uk

ISBN: 978 1 85709 702 3
1052464

British Library Cataloguing-in-Publication Data
A catalogue record is available from
the British Library
Library of Congress Control Number:
2023940077

Publisher: Laura Lappin
Project Editor: Catherine Hooper
Copy-editor: Jenny Wilson
Proofreaders: Robert Davies and
Bridget Harley
Picture Researcher: Rebecca Thornton
Production: Justine Montizon and Jane Hyne

Designed by Sandra Zellmer
Cover design and map by Louise Nyborg
Origination by DL Imaging, London
Printed in Belgium by Graphius

All works are by Jean-Etienne Liotard
(1702–1789) unless otherwise stated.

All measurements give height before width.

Front cover and pages 1, 8, 10, 76, 78, 100,
108 and 111: *The Lavergne Family Breakfast*,
1754 (details from fig. 1)
Back cover: *Still Life: Tea Set* (detail from
fig. 51)
Frontispiece: Self portrait proof (detail
from fig. 16)
Pages 11, 77, 79, 101 and 109: *The Lavergne
Family Breakfast*, 1773 (details from fig. 2)

DIRECTOR'S FOREWORD

As the title of the exhibition states, this is an opportunity to discover Jean-Etienne Liotard and *The Lavergne Family Breakfast* of 1754, a pastel painting of sublime elegance and virtuosity. It is, arguably, the masterpiece of the Swiss artist, perhaps the most distinguished master of the pastel medium in the eighteenth century, or ever.

The painting – this is the correct terminology in spite of the fact that it is chalk dust on paper and brushes were used minimally, if at all – was acquired for the National Gallery in 2019 through acceptance in lieu of inheritance tax, a procedure that has brought many important works of art into public museums in this country. The previous owner, George Pinto, a merchant banker and prominent supporter of Jewish causes, had looked after the painting with a zealous care, keeping it mostly in the dark in his house near Canterbury to prevent any fading and refusing to lend it to any temporary exhibitions. It was shown to very few people. Yet he was adamant that it should eventually come to the National Gallery, which it did after his unexpected death in 2018. Instrumental in making this happen were his family, Sir Simon Robertson, Francis Russell of Christie's and, of course, the British government. We are grateful to them all.

The exhibition brings together, for the first time since Liotard's lifetime, the pastel and its oil painting replica that the artist made almost twenty years later in 1773. We owe to the current owner of that work a debt of gratitude, as we do to all those – both museums and private collectors – who have been so kind as to lend their artworks to this exhibition, affording the visiting public the opportunity to discover, learn and enjoy. I would like to express my appreciation to the exhibition curator and principal author of this catalogue, Francesca Whitlum-Cooper, for enabling this to happen.

It is a pleasure to thank the Bernard Sunley Foundation for their long-standing support of the Sunley Room exhibition programme. I am also grateful for the continued generosity of the Thompson Family Charitable Trust and their support of exhibitions at the National Gallery. Lastly, I would like to thank Katrin Henkel and other donors who have supported *Discover Liotard & The Lavergne Family Breakfast*.

Gabriele Finaldi
Director, The National Gallery

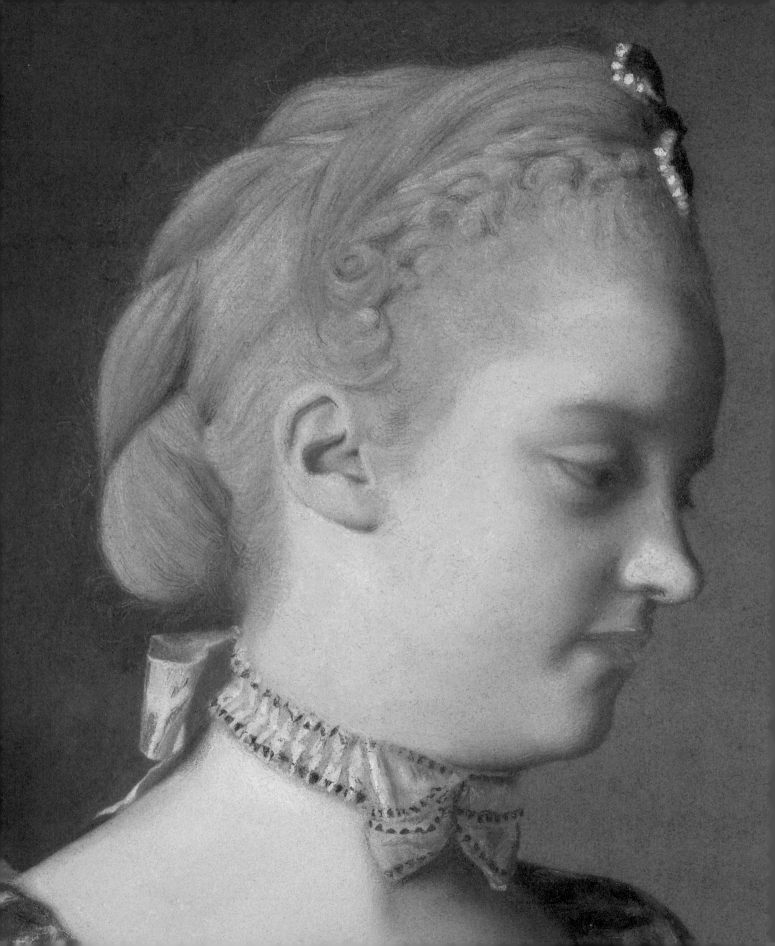

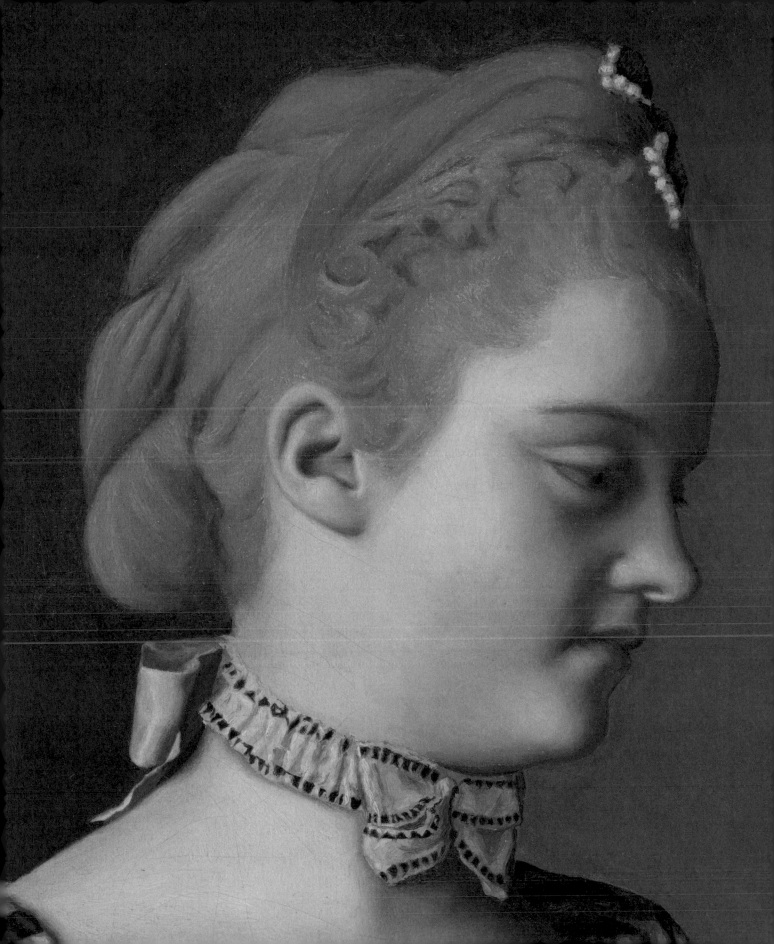

Fig. 3
Map outlining the journeys
Liotard made over his lifetime.
Eighteenth-century place
names are used and dates are
given if known:

Geneva (up to 1723)
Paris (1723–35)
Rome (1735, via Marseille)
Naples (1735–6)
Rome
Florence
Rome
Naples (by 1738)
Capri
Messina
Syracuse
Malta
Chios
Paros
Milos
Smyrna
Constantinople (1738–42)
Jassy, Moldavia (1742–3)
Vienna (1743–5)
Venice (1745)
Vienna (1745)
Frankfurt (1745, via Bayreuth)
Darmstadt (1745 or 1746)
Geneva (1746)
Lyon (1747–8)
Paris (1748–52)
Lyon (1752)
Paris (1752)
London (1753–4)
Lyon (1754–5)
London (1755)
Delft (1755)
The Hague (1755)
Amsterdam (1756–7)
Paris (1757)
Geneva (1757–62)
Vienna (1762)
Geneva (1763–70)
Paris (1770–1)
Amsterdam (1771)
Delft (1771?–2)
London (1772–4)
Geneva (1774–7)
Vienna (1777–8)
Geneva (1778)
Lyon (1781)
Geneva (1781–9)

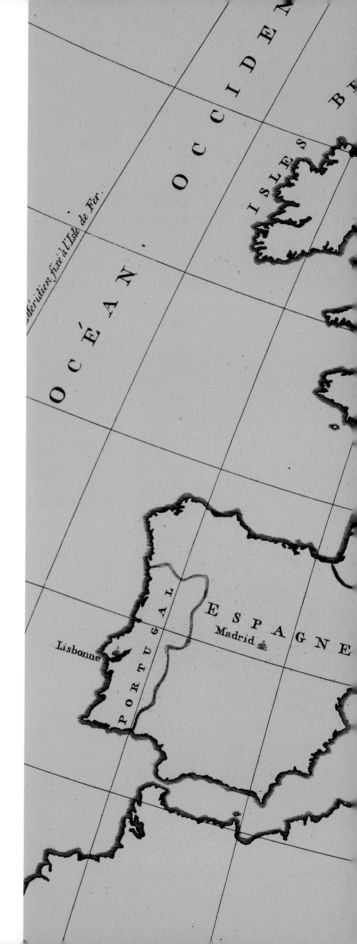

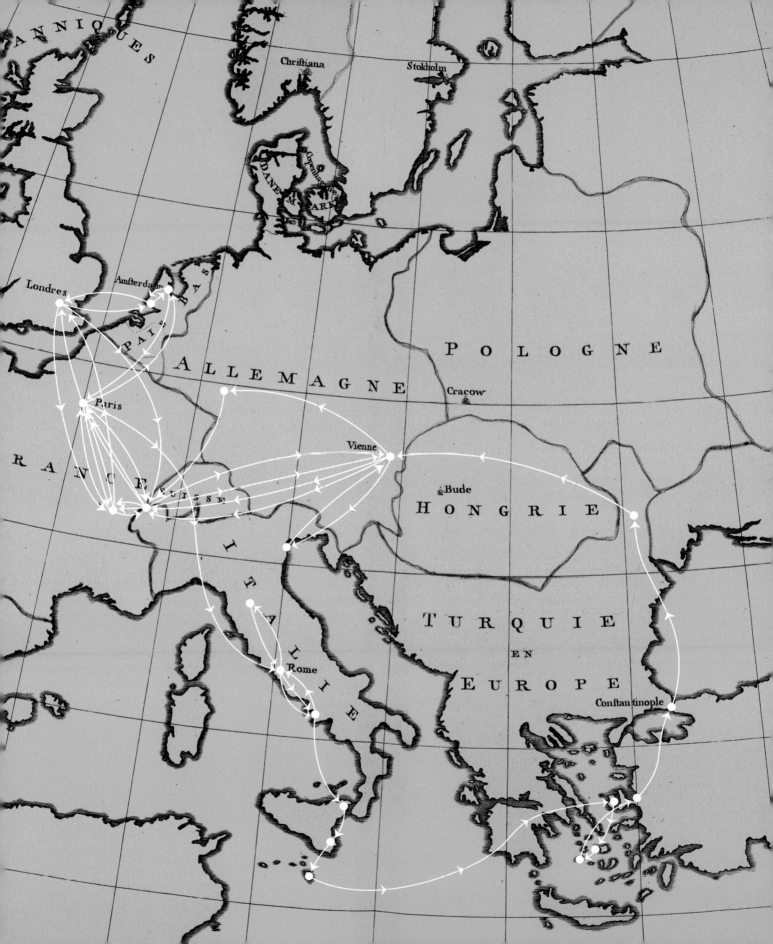

FRANCESCA WHITLUM-COOPER

The Many Faces of Jean-Etienne Liotard

An artist turns to look at us, eyes wide, mouth open, his hand raised in front of his easel (fig. 4). We seem to have interrupted both his work and whatever it was he was saying to us. The easel and the prominently raised hand make clear to us his profession, but little else about this picture conforms to the tradition of how artists painted themselves in the eighteenth century. This artist sits cross-legged on his chair. He wears an extravagant costume: a kaftan of plush red velvet; a blue gown in shot and patterned silk; a belt with two decorated metal roundels. Most unusual and, in this picture, completely unavoidable is his silver beard, which cascades in tight, wiry curls almost to his elbow.

This is Jean-Etienne Liotard (1702–1789), one of the most immediately recognisable artists of eighteenth-century Europe. Liotard's career took him from his native Geneva across the length and breadth of Europe: from Paris in the west to Constantinople in the east; from the courts of Vienna and Versailles to commercial centres such as Amsterdam and Lyon. His life and work were shaped by four years spent living in Constantinople, present-day Istanbul (1738–42), after which he grew this extraordinary beard and adopted Turkish dress. Liotard was exceptionally proud of both, boasting of this portrait that he had not omitted 'a single hair' from his beard.[1] This technical precision was characteristic of Liotard, who worked in oil, chalk and enamel, and even painted on glass. But he was most celebrated for his paintings in pastel – soft, coloured crayons that produced rapid, luminous likenesses. It is pastel that Liotard used to paint this *Self Portrait with a Long Beard*, and a work in pastel that he appears to be preparing in it, a blue stick poking out of his *porte-crayon*.[2]

Fig. 4
Self Portrait with a Long Beard, about 1751–2
Pastel on paper mounted on canvas, 97 × 71 cm
Musée d'art et d'histoire, Ville de Genève

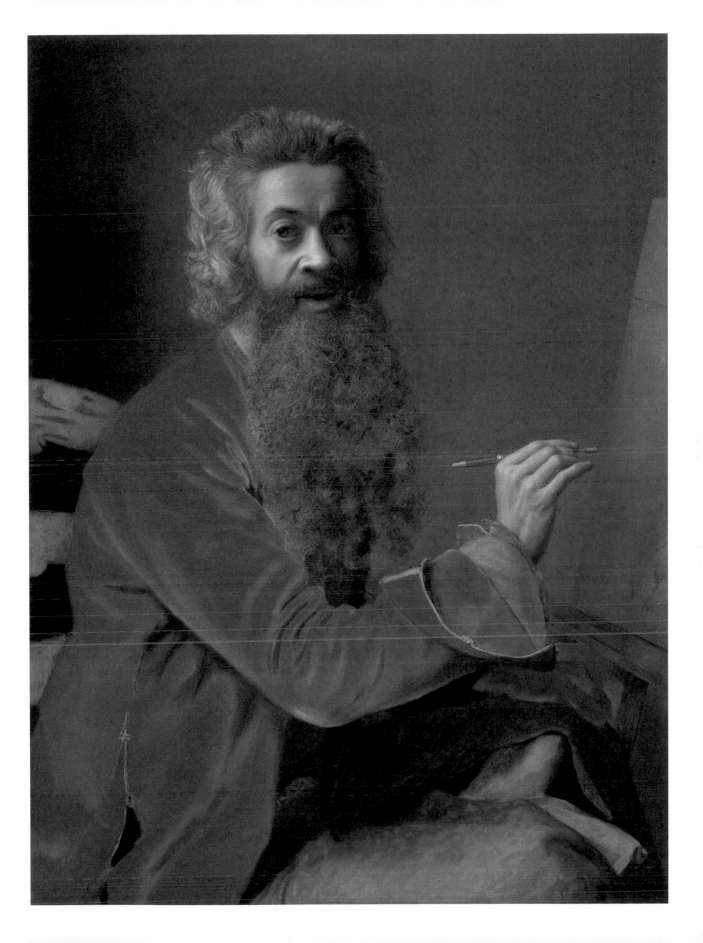

Liotard enjoyed painting his own image. Over the course of five decades, he produced more than twenty self portraits in a wide variety of media.[3] Only one of these, however, was commissioned by a patron, the rest seemingly satisfying Liotard's own desire to paint himself into being. Today, we are familiar with the idea of artists using themselves as model: from Vincent van Gogh (1853–1890) to Lucian Freud (1922–2011), obsessive self portraiture is such a frequent practice as to seem commonplace. But while artists certainly did use their own likenesses in the eighteenth century, Liotard has left us more self portraits than almost all his contemporaries.[4] Even if there were practical reasons for this – an artist can always turn to self portraiture if paying clients are scarce, or if they refuse the long sittings demanded by such a meticulous artist – Liotard's self portraits have become a defining part of his practice. To follow these self portraits – painted across half a century and across a continent – is to trace the journey of this artist, who was both prolific and peripatetic, endlessly innovative and, as we shall see, highly idiosyncratic.[5]

Portrait of the Artist as a Young Man

Four of Liotard's self portraits show us what he looked like as a young man; that is, before the journey that led him to don Turkish garb and grow his much-talked-of beard.[6] One of these is an etching, modest in scale and closely cropped, presenting the artist's head up close to the viewer (fig. 5). We see Liotard's wide eyes and his bulbous nose. His cheeks are shaved, his hair in conventional – if somewhat unruly – curls. The work was made in Paris in about 1733. This is Liotard before he became Liotard, as he struggled to find his way in the Parisian art world.

Liotard was born in Geneva in 1702 to French Huguenot parents – namely, French Protestants who had fled their homeland following the Revocation of the Edict of Nantes in 1685, which effectively outlawed their religion. Liotard's father, Antoine Liotard (1661–1740), was a *marchand-tailleur*, a businessman in the fabric trade who intended his son for the same profession. But according to his two manuscript autobiographies, Liotard was such an artistic prodigy that his father had to be begged – 'persecuted by his friends' is the phrase – to allow his son to train as an artist.[7] Liotard, however, was not someone who enjoyed being taught. Descriptions of both his apprenticeship in Geneva to the miniaturist Daniel Gardelle (1679–1753) in the mid-1710s and his time in Paris in the studio of Jean-Baptiste Massé (1687–1767) in the mid-1720s are littered with dissatisfaction. After four months, Liotard left Gardelle's studio 'as talented as his master'.[8] Massé had 'no talent for teaching'.[9] These accounts of his early years also give us a sense of Liotard's fiery personality and his keen sense of injustice. Accused by Gardelle of tracing a drawing rather than making his own copy, Liotard tells us that he cried 'hot tears', as he would in Vienna when falsely accused of stealing a jewelled miniature, while in London he lay 'senseless and afraid' on the ground after a young boy pulled at his beard to

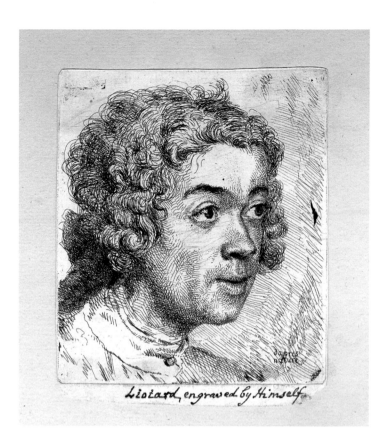

Fig. 5
Self portrait, about 1733
Etching on paper, 11.7 × 10.1 cm
One of three portraits of Liotard
mounted on a sheet from an
album formerly in the collection
of Horace Walpole (see fig. 12)
British Museum, London

see if it was real.[10] There is a recurrent trope, too, of Liotard's success being
of his own making.

This sense of self-sufficiency is not surprising. If we think it is difficult to
break into the art world today, the same was certainly true of eighteenth-century
Europe, where artists' careers depended heavily on their familial connections,
either for advancement or to place them in a studio for training. In Paris,
artists were often expected to have trained in the schools of the Académie
Royale de Peinture et de Sculpture and to have their candidature for membership
supported by other academicians.[11] Liotard, in Paris, had to work outside
the Académie: throughout his life, he pursued his own distinctive manner of
painting, which was wholly at odds with the prevailing currents of academic
teaching.[12] He and his twin brother Jean-Michel (1702–1796) initially found
work as engravers. According to his autobiographies, Liotard succeeded in
becoming a portraitist: 'Eventually all the Nobility wanted to have their portraits
painted by his hand.'[13] But the paucity of surviving pictures from these years
would seem to tell a different story. After a failed attempt in 1732 to win the
Académie's Prix de Rome, which would have paid for him to travel to and study
in Italy, Liotard decided to do things his own way.[14] In the autumn of 1735, after
12 years in the French capital, he struck out for the south, joining the retinue
of the Marquis de Puysieux (1702–1770), French ambassador to Naples.

Plenty of French artists travelled to Italy during the eighteenth century, but in most cases their journeys were sponsored, their destination the Académie de France à Rome where their education would be furthered by the study of ancient and modern masters. Liotard, by contrast, found his own market in Rome, painting portraits of cardinals and of James Stuart (1688–1766), the so-called 'Old Pretender' to the English throne, and his sons, as well as pastels of some of the most celebrated antique sculptures.[15] But if his autobiography is to be believed, it was a chance meeting that changed the course of Liotard's life. One winter's day in Rome, he entered a café and met a group of English noblemen on their Grand Tour. A rite of passage for wealthy young men, the Grand Tour was a cultural phenomenon in the eighteenth century – part cultural education, part shopping expedition, taking in the great cities and sites of Europe.[16] The men in question were, Liotard wants us to believe, discussing a beautiful miniature that they had seen in Paris, and he was thrilled to tell them that he was in fact its artist. Some months later, he bumped into one of these travellers again. That man was William Ponsonby (1704–1793), then Viscount Duncannon, later 2nd Earl of Bessborough, and he would become Liotard's most important patron. This chance meeting in the street gave Liotard an exciting opportunity: Ponsonby was leaving in four days' time for Constantinople – did Liotard want to go with him?

Becoming the Turkish Painter

Setting sail from Naples on 3 April 1738, Liotard and his companions – who included the 4th Earl of Sandwich (1718–1792), a Scotsman named John Mackye (1707–1797) and an English gentleman called James Nelthorpe (1719–1767) – charted a course around the boot of Italy and then across the Ionian Sea. They stopped in Sicily and Malta, visiting several Greek islands before arriving in Smyrna (modern-day İzmir). This itinerary was documented by Liotard in a series of exquisitely detailed red and black chalk drawings. Depicting single full-length figures, several of these sheets note their date and location, such as the *Portrait of Signora Marigot, Smyrna* (fig. 6). The precise dating of this striking portrait, prominently inscribed 'Sᵃ Marigot Smirnien[ne] / May 1738', vividly evokes Liotard's journey to the Ottoman Empire. Liotard portrays Signora Marigot's confident pose and elegant profile with a remarkable economy of means, making extensive use of bare paper to create the folds of her gown and the elaborate ornaments in her hair. Her complexion is drawn with an almost pointillist technique, characteristic of an artist who was at home on a miniaturist's scale. On other drawings, such as the *Portrait of Signora Maroudia Stay in Summer Attire, Milo* (fig. 7), Liotard wrote himself a detailed description of the sitter's garments, giving us the first hint of an artist creating an image bank for future work, building up a stock of visual references to which he would return.[17]

Fig. 6
Portrait of Signora Marigot, Smyrna, 1738
Red and black chalk on paper, 21.5 × 13.5 cm
Musée du Louvre, Paris

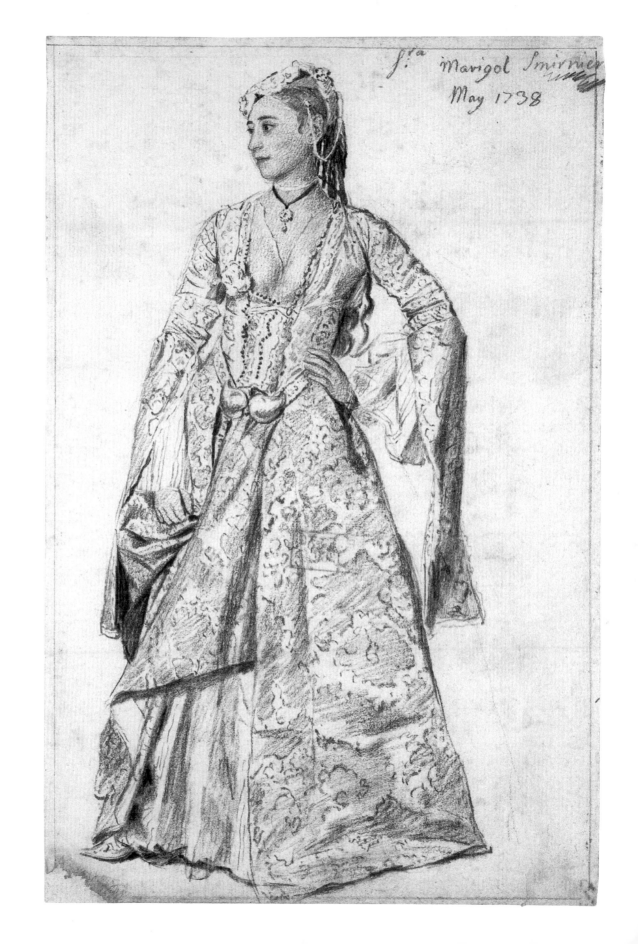

Sra Marigol Smirnie
May 1738

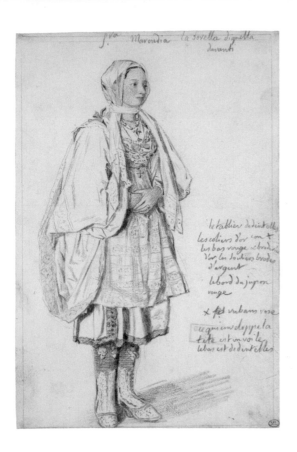

About fifty drawings survive from the years Liotard spent in
Constantinople, ranging from loose sketches seemingly made to capture
a particular moment to meticulous portraits.[18] In theory, he had been
engaged to provide his patrons – especially Sandwich, who was leading the
expedition – with drawings of the people, places and antiquities they saw
along the way: 'to draw the dresses of every country they should go into;
to take prospects of all the remarkable places which had made a figure in
history; and to preserve in their memories, by the help of painting, those
noble remains of antiquity which they went in quest of'.[19] It was a common
practice on a Grand Tour voyage to take an artist for just such a purpose.
But Liotard made no drawings of sites or ruins that we know of, and the
vast majority of the drawings that survive from his voyage to and years in
Constantinople appear to have been made for himself alone.[20] These sheets
were personal: Liotard kept them with him for the next 40 years, exhibiting
them in Paris (1752 and 1771) and London (1753–4), until he sold them
to a collector in 1778.[21] Some, such as *Woman from Constantinople sitting on
a Divan* (fig. 8), remained an important source for the artist, their minutely
observed costumes reappearing in future commissions.[22] Others, such as
the portrait of explorer and theologian Richard Pococke (1704–1765; fig. 9),
show Liotard's skill at capturing his British sitters in Turkish dress.

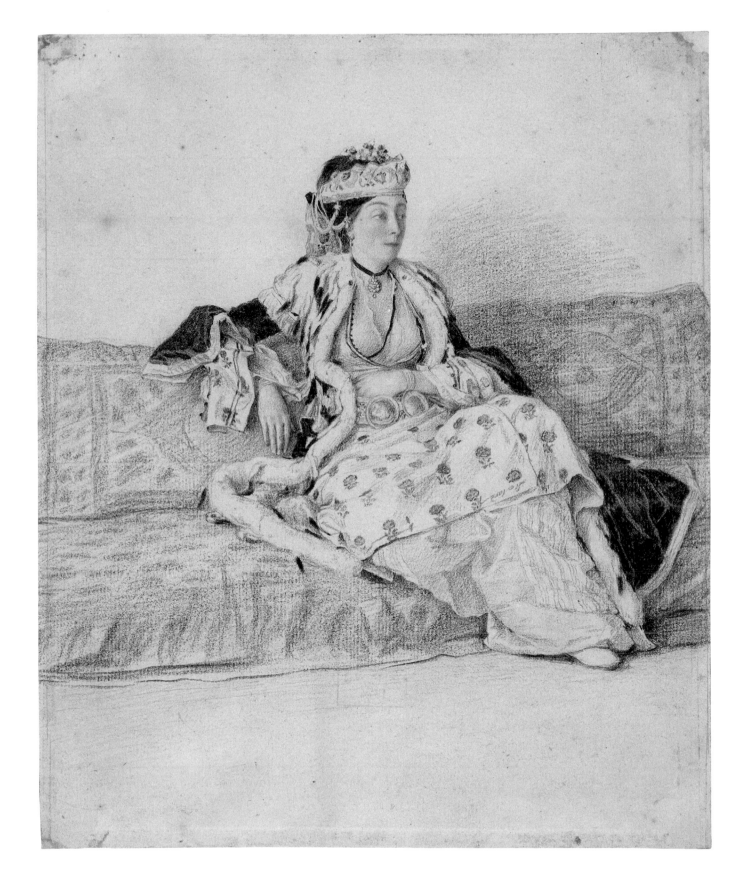

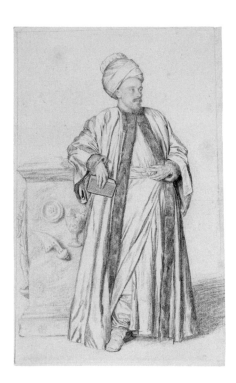

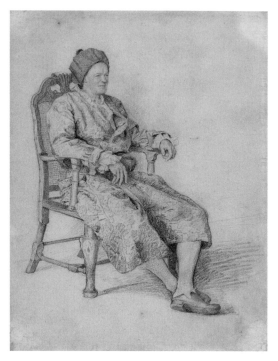

With his tightly bound turban and fur-lined robe, Richard Pococke reveals the taste for *turquerie* during the eighteenth century. *Turquerie* can be defined as a Western European fascination with all things (including those incorrectly perceived to be) Turkish. It encompassed both genuine interest in and the wild fantasies of an 'imagined orient', finding form in all the visual and decorative arts of the eighteenth century, as well as the fashions and the literature.[23] It undeniably played on racial (often racist) stereotypes. What today would be perceived as cultural appropriation – the act of donning someone else's traditional dress, which all the travellers in Liotard's group did[24] – was then extremely common, an act intended to illustrate a person's worldliness, the literal and metaphorical breadth of their travels and education. And while Europeans had established embassies and trading posts in the Ottoman Empire far earlier than their counterparts had done in Western Europe, it should be remembered that travel was a two-way street. Turkish embassies to Paris in 1721 and 1742, for example, brought hundreds of Ottomans into the French capital for the first time, generating huge interest in all things *à la turque*.[25] Then as now, Constantinople was a meeting point of cultures, straddling the boundary between Asia and Europe. Although the city Liotard encountered was far from unknown to European travellers – indeed, some of the most celebrated travel writing of the eighteenth century covered journeys to it – it was not part of the 'standard' Grand Tour itinerary, which tended to focus more on France, Italy and Germany.[26] It was clearly a city that struck a chord with Liotard, for Sir Everard Fawkener (1694–1758), British ambassador to Constantinople (fig. 10),

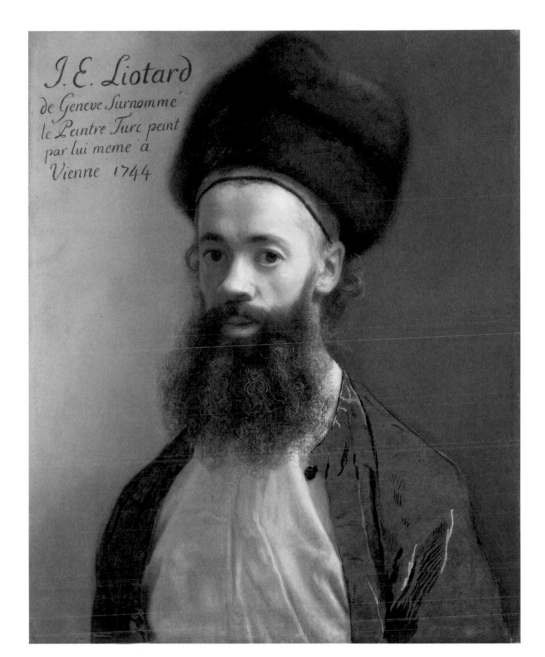

J. E. Liotard de Geneve Surnommé le Peintre Turc peint par lui meme a Vienne 1744

Fig. 9
Archaeologist and Theologian Richard Pococke, about 1738–9
Red and black chalk on paper,
21 × 13 cm
Musée du Louvre, Paris

Fig. 10
Sir Everard Fawkener (1694–1758), British Ambassador to the Sublime Porte, dressed in Turkish Costume, about 1738–42
Red and black chalk on paper,
22.5 × 17.4 cm
Norwich Castle Museum & Art Gallery

Fig. 11
Self Portrait as the Turkish Painter, 1744
Pastel on paper, 61 × 49 cm
Galleria degli Uffizi, Florence

offered to intercede with Liotard's travelling companions and request that they allow him to remain in the city.[27]

The Liotard who departed Constantinople four years later for Moldavia was very different, in appearance at least, from the man who had arrived on the ship with Ponsonby and Sandwich. His appearance is recorded for us in another self portrait (fig. 11). This is the first time we see the famous beard, shorter and darker here than in the Geneva self portrait, but nevertheless a radical departure from the norms of Western European fashion. Liotard sports a large fur tocque over a red fez, a loose shirt and a brown kaftan. In a strange

and deliberate show of bravura, this kaftan is left radically unfinished, as if to emphasise the talent of an artist who could turn such loose strokes of pastel into the verisimilitude of the highly finished face. Most striking of all is the bold black inscription, in Liotard's own hand: 'J. E. Liotard / from Geneva nicknamed / the Turkish Painter painted / by himself in / Vienna 1744'.

Setting out from Constantinople, this was how Liotard positioned himself: as the Turkish Painter, an artist who dressed in Ottoman garb and who could – thanks to his first-hand experience of the Ottoman Empire – paint his sitters in Turkish dress. After 10 months at the court of Jassy (present-day Iași, Romania), working for Prince Constantin Mavrocordat of Moldavia (1711–1769) who had heard about him in Constantinople, Liotard headed west. He arrived in Vienna on 2 September 1743 and remained for a year and a half – the first of three extended stays in the capital of the Habsburg Empire. His autobiography tells us that he introduced himself to Franz Stefan (1708–1765), husband of Archduchess Maria Theresa of Austria and later Holy Roman Emperor, in the street, the latter having heard of a 'famous painter' newly arrived from Constantinople.[28] Liotard went on to paint dozens of portraits at the Viennese court. Over the subsequent decades and return visits to Vienna in 1762 and 1777–8, the Empress Maria Theresa (1717–1780) would become one of his most steadfast patrons, even acting as godmother to one of Liotard's daughters. It was as a commission from Franz Stefan that he painted himself as 'the Turkish Painter'.

The Courtly Years

For the next 35 years, Liotard continued to travel between the courts and commercial centres of Europe. The list of cities in which he worked is quite extraordinary: Venice (1745), Frankfurt (1745), Darmstadt (1745 or 1746), Geneva (1746), Lyon (1747–8), Paris (1748–52), Lyon (1752), London (1753–5, including a visit to Lyon in 1754), Delft (1755), The Hague (1755), Amsterdam (1756–7), Paris (1757), Geneva (1757–62), Vienna (1762), Geneva (1763–70), Paris (1770–1), Amsterdam (1771), Delft (1771?–2), London (1772–4), Geneva (1774–7), Vienna (1777–8). One impetus for this constant displacement might have been Liotard's preferred medium: as we will see in Chapter 2, works in pastel were extremely fragile and it may, to some extent, have been easier for a pastellist to move between patrons in different cities than to send his works.[29] Another may have been Liotard's particular ability to market himself, and his skill at seeking out new patrons and new commissions in different cities. A third may have been the *need* to find new patrons after initial periods of success in a given city. Yet plotted visually (see fig. 3), these journeys show an artist who, as time went on, created an increasingly familiar circuit for himself. Perhaps a better way to think of Liotard's travels is to observe that he made different uses of different cities. Lyon, as discussed in Chapter 3, was a city with strong family connections, where he could count on nieces and nephews to sit for pictures that he could sell elsewhere. London, by contrast, to which he made two extended visits, was a city rich in possibilities for portraiture.

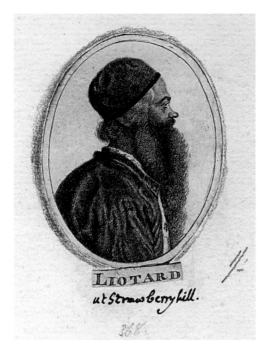

Fig. 12
Three portraits of Liotard mounted
on a sheet from an album formerly
in the collection of Horace
Walpole, about 1750–70. Detail
shows the middle portrait
Etchings on paper, 40.2 × 21.5 cm
British Museum, London

It was taken as fact in eighteenth-century Europe that the British were
obsessed with having their portraits painted. For one French writer, England
was 'the country where they do the most portraits and where they're most
highly paid for [them]'.[30] For another, England offered patrons with 'little
education, [and] lots of Money to spend'.[31] This was a winning combination for
an artist like Liotard, whose principal production was portraiture. Settling in
London in 1753, it seems that Liotard met his goals. Horace Walpole (1717–1797),
the author, antiquarian and art collector who assembled a sheet of images of
Liotard for his collection (fig. 12), marvelled at a viscountess having her four
daughters painted by the artist 'as his price is so great'.[32] Joshua Reynolds
(1723–1792), later first President of the Royal Academy, fumed that a head by
Liotard in pastel cost more than his own full-length oil portraits, noting that
one could 'smell something of the Quack from his appearance the long beard
[and] Turk's dress which as wel[l as] his behaviour is of [the] very essence
of Imposture'.[33] Reynolds might have railed against his Turkish dress, but,
as demonstrated in Chapter 3, Liotard's visit to Constantinople helped him
in diverse ways in London and prompted him to paint another of his self
portraits (fig. 13).

A fraction of the size of *Self Portrait with a Long Beard* (see fig. 4),
this likeness of Liotard would sit comfortably in the palm. Unlike the velvety
softness of his pastel self portraits, this likeness is painted on enamel, its
smooth surface endowed with a high shine, its brushwork almost pointillist
in technique. The artist appears in profile and spares us no detail: his eyelashes
extend just beyond the bridge of his nose; his nostrils flare, as if he is breathing.

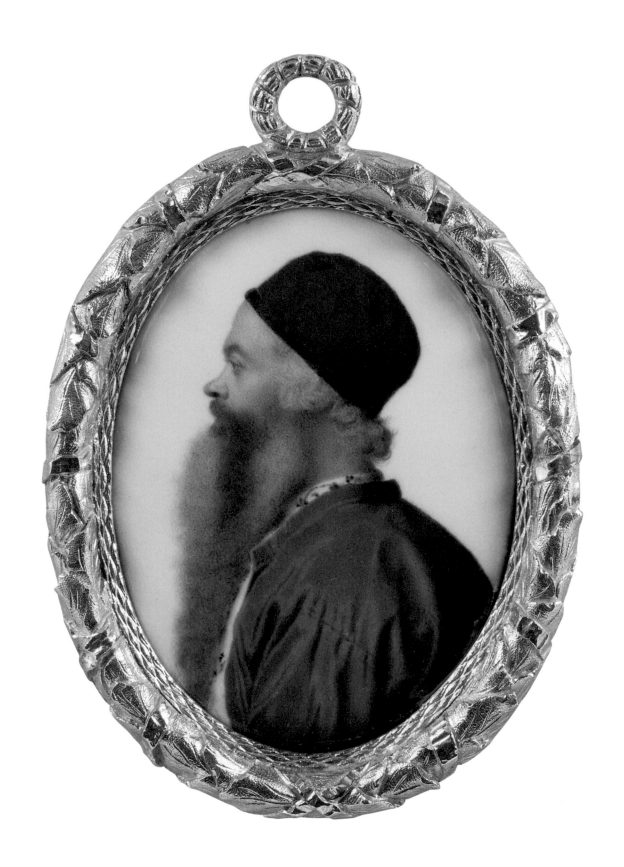

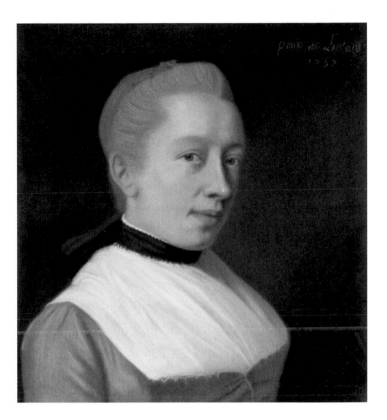

Fig. 13
A Self Portrait, about 1753
Enamel, 5.9 × 4.5 cm
The Royal Collection /
HM King Charles III

Fig. 14
*The Artist's Wife, Marie Liotard,
born Fargues, 1757*
Pastel on parchment,
44.5 × 41 cm
Musée des beaux-arts, La
Chaux-de-Fonds, Collection
René et Madeleine Junod

Again we see that celebrated beard, extending here to the edge of the painted surface, but from this angle we are privy, too, to the delicate curls at the nape of the artist's neck and the tiny embroidered flowers that dance along his collar. This may be a small object, but the figure within it feels substantial, with his tomato-red cap, the puckers and folds of his raspberry jacket, the wiry volume of his beard. Inscribed on the back 'Liotard / by / Himself', this self portrait was presented by Lady Mary Churchill to Horace Walpole, in whose collection at Strawberry Hill it remained and where it was engraved (see fig. 12).

The Later Years

Following his departure from London in 1755, Liotard, who was by then 'rich and famous',[34] established himself in the Low Countries: first in Delft, where he had family connections and was able to lodge with his nephew; then in The Hague; and finally in Amsterdam. It was here in 1756 at the age of 53 that he married Marie-Anne Fargues, a young woman some quarter of a century his junior, also from a family of French Huguenots (fig. 14). Several eighteenth-century accounts of Liotard's life suggest that she made it a condition of their marriage that he cut off his beard![35] From 1757 they set up home in Geneva and while Liotard continued to travel, often remaining abroad for years at a time, his journeys were frequently punctuated by long stays in his native city. Six children were born to the couple between 1758 and 1767.

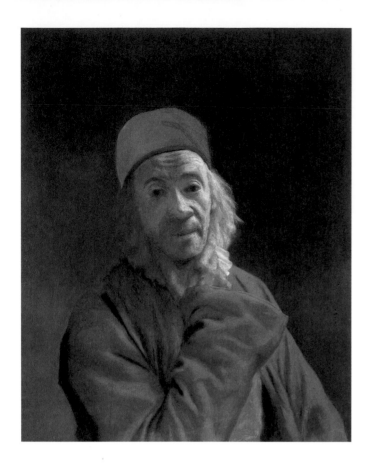

Fig. 15
Self Portrait with Hand on Chin,
about 1770
Wet and dry pastel and
gouache on blue canvas,
63.5 × 51 cm
Musée d'art et d'histoire,
Ville de Genève

Fig. 16
Self portrait proof, about
1778–80
Roulette and engraving over
mezzotint, 48 × 40 cm
British Museum, London

Liotard continued to seize the varying opportunities that different cities offered him. It was during his time in Amsterdam, for example, that he bought the majority of the artworks that would make up his private collection – that city long having held the crown as centre of the European art market. The pictures Liotard bought were largely paintings by seventeenth-century Dutch masters whose miniaturist detail and flawless brushwork he admired. It was in Paris in 1751 that Liotard had first exhibited his work publicly, at the exhibition of the Parisian painters' guild, the Académie de Saint-Luc, and it was in Paris 20 years later, in 1771, that he organised his first private exhibition: that is, an exhibition of his own works and works from his collection, held at his address on the rue Montmartre. This was a model he followed again during his second visit to London in 1773 at his home on Great Marlborough Street. In addition to these private selling exhibitions, neither of which was a great commercial success, Liotard exhibited five pastel portraits at the Royal Academy in 1771, including one self portrait (fig. 15).

Liotard was a relentless innovator, whether this was painting on enamel, or experimenting with illusionistic *trompe l'oeil* paintings, or making his 'transparencies', in which he painted onto glass that could then be held in front of a light source. It is perhaps not surprising, then, that in his late

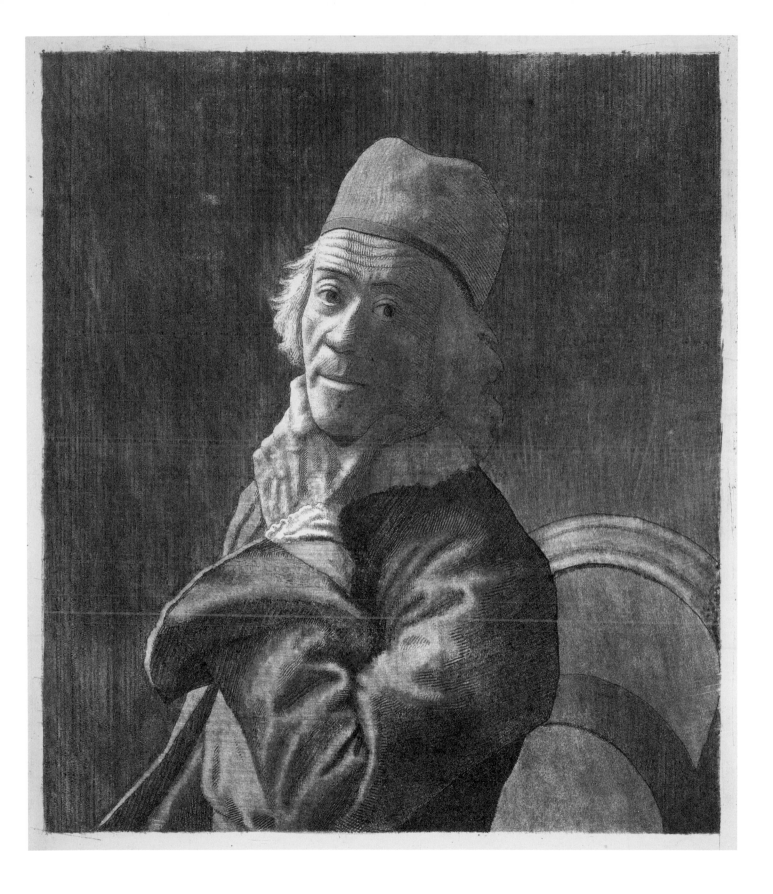

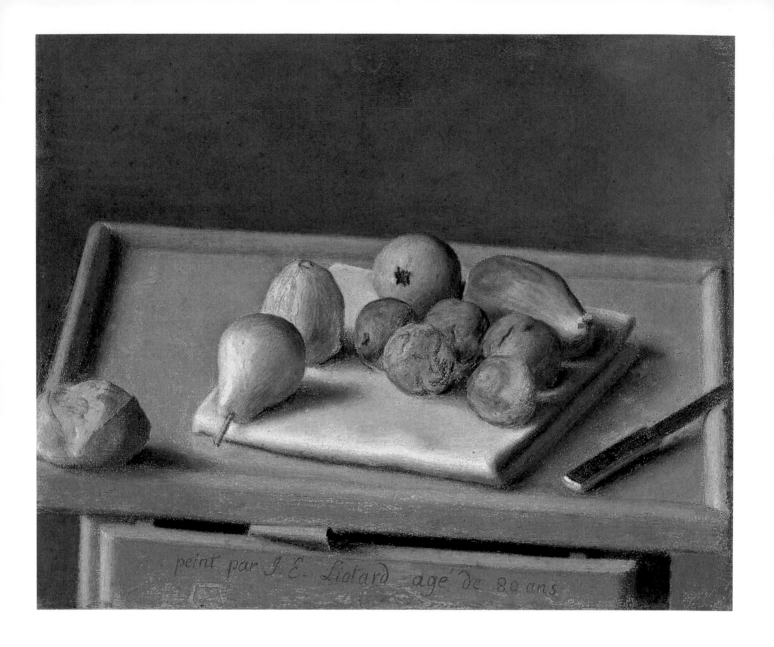

Fig. 17
*Still Life: Fruit on a Napkin,
a Bread Roll, a Knife*, 1782
Pastel on prepared canvas,
33 × 38 cm
Musée d'art et d'histoire,
Ville de Genève

seventies, Liotard took this pastel self portrait and embarked on a new technical adventure: mezzotint engraving (fig. 16). It is as if he had come full circle, starting his career with engraving in Paris and returning to a similar technique these many decades and countries later. In his mezzotint as in the pastel, Liotard meets our gaze, as if we are entering into a frank exchange. We see the freshly shaved face of youth, though he has not shied away from etching the ravages of time into his furrowed brow. In place of his beard, we see the artist's hand. Its knuckles and cuff left unworked, using the reserve of the paper to act as highlight, this hand holds the artist's chin, in equal parts contemplation and proposition, as if Liotard is pushing himself forward. At first glance, it seems as if the hand Liotard raises is not the same hand he uses to draw in *Self Portrait with a Long Beard*, but this is a result of the process of printmaking that reverses an image. It is indeed Liotard's right hand – his making hand – that he raises so prominently in the mezzotint. This hand is the tool of his trade.

That he embarked on mezzotint engraving at this advanced age stands as a metaphor for much of Liotard's career. He was always a master of self-promotion and must have relished the idea of his name and face circulating (even if, as he noted in his 1781 treatise, his technique was not as refined as he would have wished).[36] Typical, too, is this mezzotint's interest in textures and surfaces, its absolute attention to detail: from lines, dots, zig-zags and paper left blank, there is a huge variety of stroke in this work. Perhaps most compelling, however, is the fact that mezzotint engraving was a British speciality: something that Liotard encountered on his travels and took with him, much as he carried his Turkish drawings and trunks of Turkish clothes, storing up that knowledge and experience for a later moment. A series of astonishing still lifes in pastel, several painted as late as 1786, confirms that he continued pushing and adapting his technique into his eighties (fig. 17).

If Liotard's career spanned the geographic breadth of Europe, then his life spanned almost the entire eighteenth century. His death at the age of 86 on 12 June 1789 came just days before the dissolution of the Estates-General in France and the tumultuous events that would lead to the French Revolution, changing forever the continent he had spent so much of his life traversing. The Revolution coincided, more or less, with a break for the pastel medium. The popularity of pastel portraiture – which had, after all, been a luxury expense for the highest social echelons – fell dramatically away. And while Impressionists such as Edgar Degas (1834–1917; see fig. 28) or post-Impressionists like Odilon Redon (1840–1916; see fig. 29) would take up their pastel batons in the later nineteenth century, it was with a very different technique and aesthetic. As we shall see in the following chapter, pastel as Liotard used it was a particularly eighteenth-century phenomenon.

FRANCESCA WHITLUM-COOPER

'Precious Dust': The Rise of Pastel in Eighteenth-Century Europe

In 1746, Etienne La Font de Saint-Yenne (1688–1771) – one of the founding fathers of French art criticism – lamented the extreme popularity of the pastel medium. It had become, he wrote, 'excessively fashionable … Everyone has these coloured crayons in their hand.'[1] It might seem strange, today, to think that one artistic medium could sweep across a country or even a continent, but pastel did enjoy an explosion of popularity across eighteenth-century Europe.

There was the internationally renowned Venetian pastellist Rosalba Carriera (1673–1757), who is often said to have brought the craze for pastel with her to Paris in 1720–1 and who later described herself as being 'besieged by English visitors' begging for their portrait (fig. 19).[2] There was the French artist Maurice-Quentin de La Tour (1704–1788), who dazzled the Parisian art world with pastel compositions reaching up to two metres in height (fig. 20).[3] There were the collectors enchanted by these luminous, velvety images: Augustus III, Elector of Saxony and King of Poland (1696–1763), owned some 175 pastels, 157 of them by Carriera, the largest collection in Europe.[4] And there were the amateurs who took up crayons themselves. Neil Jeffares's *Dictionary of Pastellists before 1800* records the work of more than 3,000 pastellists, of whom 275 are known through a 'significant' oeuvre and almost as many can be identified as amateurs.[5] The *Dictionary* locates pastellists working in the eighteenth century from America to Russia, and from Scandinavia to Central Europe.

One would be forgiven for thinking that such a flourishing of a medium would have been matched by a flourishing of art historical attention. Pastels, however, have been somewhat overlooked. Sensitive to light and to movement, they are difficult to exhibit. Many remain in private collections. As the majority

Fig. 18
Detail from a box of Henri Roché semi-hard pastels, handmade in Paris, about 1910s, La Maison du Pastel

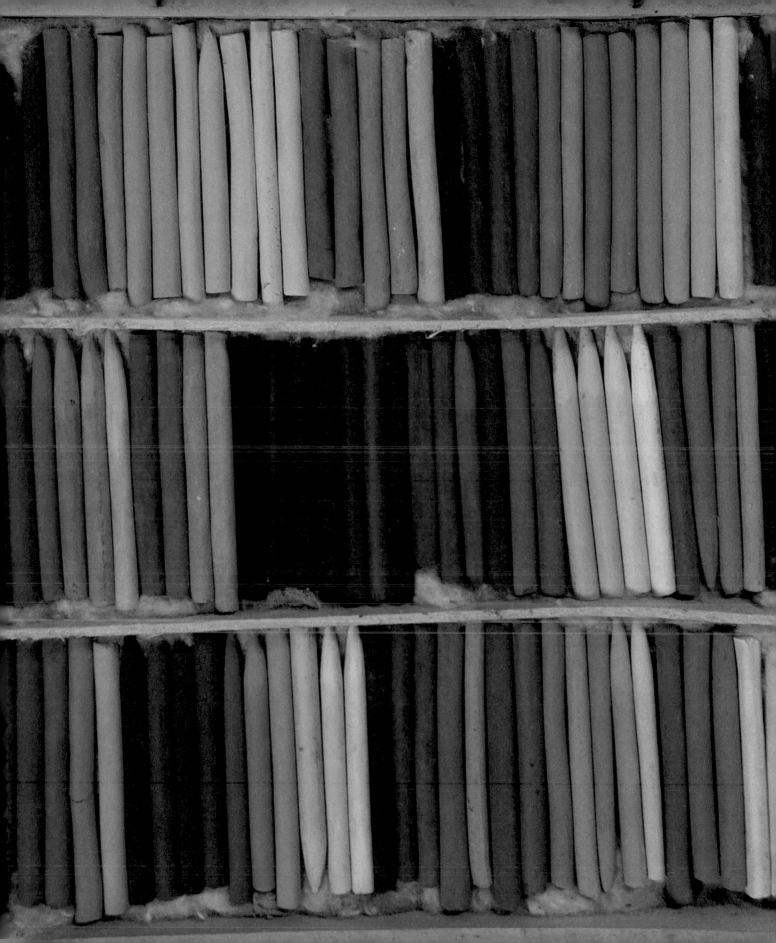

of pastels are modestly sized portraits, they are not the great, grand history paintings that pepper art historical syllabuses or museum guidebooks. For many people, pastels remain enigmatic: works on paper, produced without a brush, that look like paintings but have some of the qualities of drawings. What exactly, then, do we mean by the term 'pastel'? Should works in pastel be thought of as paintings or drawings? What caused this sudden surge of popularity during the eighteenth century, and what led to the medium's decline? These are the questions this chapter sets out to answer.

Raw Materials

The word 'pastel' plays multiple roles. It denotes both the sticks of coloured material that produce the work of art (fig. 18) and the work of art itself. Where we discern a linguistic and physical difference between oil paint, painting in oils and an oil painting, 'pastel' encompasses medium and method, painterly process and finished product. 'Pastel' is both the beginning and the end.

From the earliest cave art right through the Renaissance and beyond, artists have used sticks of chalk for drawing. Before industrial processes took over, these sticks of chalk were cut from naturally occurring blocks of minerals. White, black and red chalks were the most common, but brown and yellow chalks were also used.[6] The drawings made with these chalks had,

as one would expect, a relatively small chromatic range, since they relied on natural materials that had both colour and the appropriate texture to draw with. By the sixteenth century, however, artists had recognised the value in having a wider range of colours available for their preparatory works and had begun to make coloured crayons themselves. Thus begins the story of pastel.

Unlike chalk, pastel must be manufactured. Rather than being cut from the earth, these sticks of pastel (known as crayons) are made by mixing pigment, filler and binder. Pigment is what gives pastel its colour. Ground down to a fine powder, the pigment or mix of pigments is then combined with a filler, often something pale in colour and chalky in consistency like kaolin or gypsum. The filler gives the crayon form and bulk, while the binder (usually a gum or glue) holds the two together. This paste (from which the word 'pastel' derives, via the Italian *pastello*[7]) would then be rolled into sticks and left to dry. The production process was extremely laborious and time-consuming, and must have been largely restricted to those artists who had enough workshop assistants to whom they could hand the task. With this limited use, pastels remained a primarily graphic medium: that is, one used in a mostly linear manner for drawings. It was the development of pastels soft enough to be applied over larger passages, not only lines, that led to the emergence of pastel painting.

Painting in Pastel

Several technological innovations played into the proliferation of the pastel medium in the eighteenth century. First, there was the expansion and improvement of European glass manufacture, which was essential for protecting these vulnerable works. While the technology had existed in the seventeenth century to blow sheets of glass large enough to cover a work in pastel, these sheets had been almost prohibitively expensive.[8] Although the need to pay for glazing as well as the work of art itself doubtless added to pastel's appeal as a luxury object, greater production of glass and reduced costs presented new possibilities for pastellists. Second, there was a great deal of attention given to fixatives and the development of gum and glue mixtures that, if sprayed finely onto the surface of a pastel or soaked through the back of it, might hold the powdery material in place without damaging it. In France, such experiments reached a fever pitch when the inventor Antoine-Joseph Loriot (1716–1782) demonstrated the subtlety of his technique at the Salon exhibition of 1763 by fixing only one half of a pastel portrait of himself (fig. 21).[9] Visitors were left to guess which half, since both the fixed and unfixed pastel looked the same. Third and most crucial for pastel's development, however, was the manufacture of readymade crayons.

From the second half of the seventeenth century, it was possible to purchase pre-made pastels in several European cities. By the first decades of the eighteenth century, this manufacture had grown exponentially. At a stroke, this removed weeks of work for a studio assistant to make, roll and dry pastels. Uniform in size and softness, these crayons offered artists

Fig. 21
Jean Valade (1710–1787)
*Portrait of the Inventor
Antoine-Joseph Loriot
(1716–82)*, about 1763
Pastel on paper, 80 × 70 cm
Musée Antoine Lécuyer,
Saint-Quentin

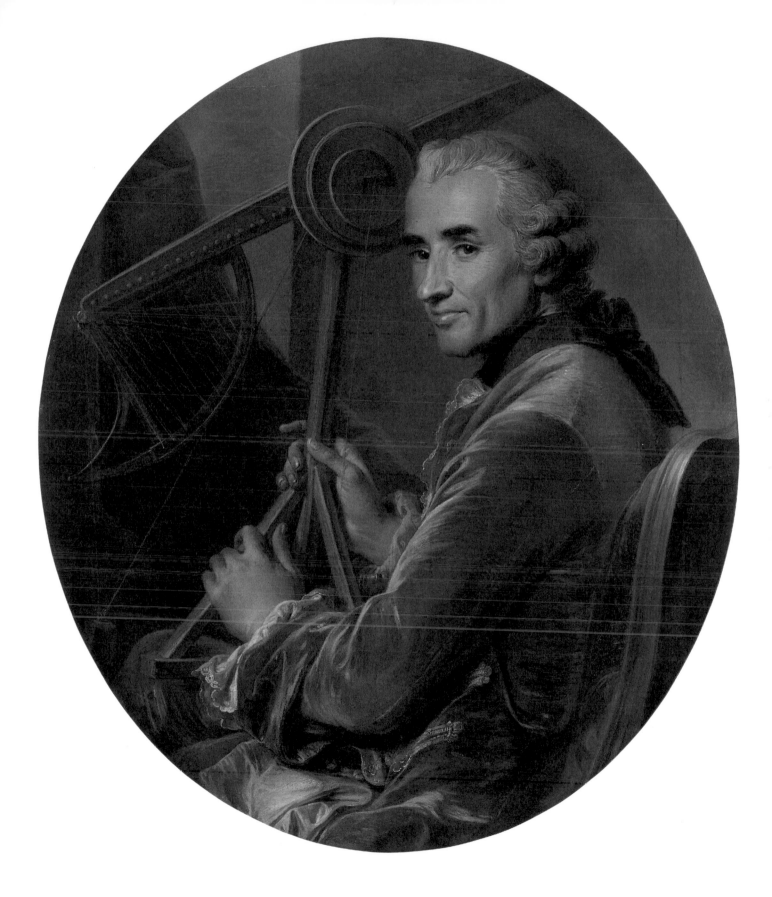

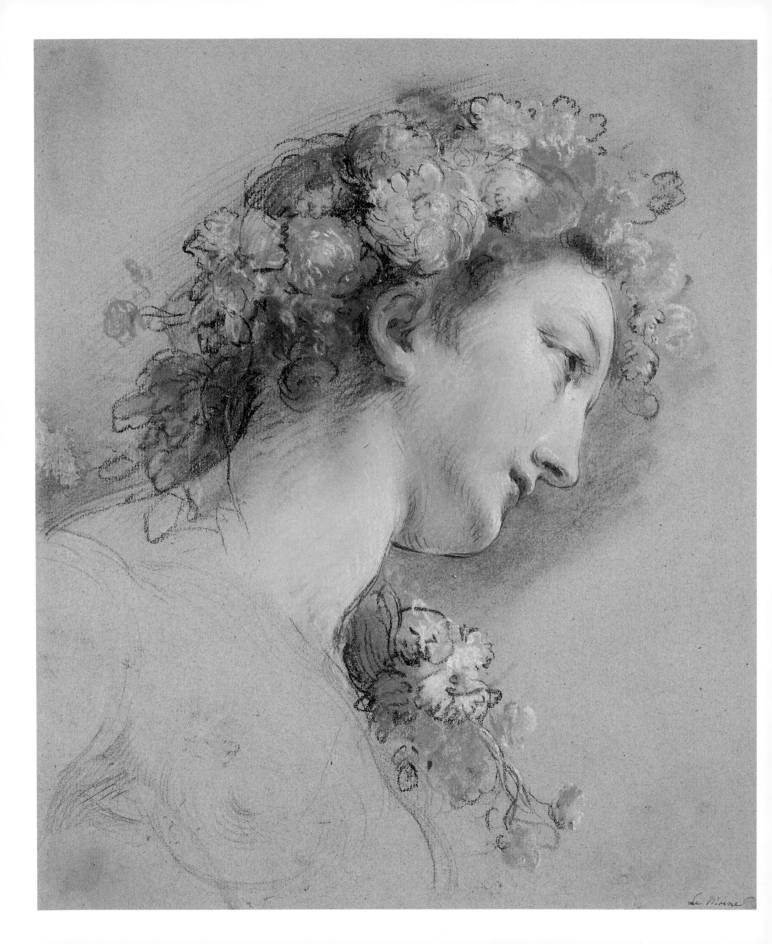

2 mm

Fig. 22
François Lemoyne (1688–1737)
Head of Hebe, Study for the 'Apotheosis of Hercules',
about 1734
Pastel over red, black and white chalk on blue paper,
30.9 × 25.6 cm
British Museum, London

Fig. 23
Photomicrograph of the lips of the child in *The Lavergne Family Breakfast* (fig. 1), showing the velvetlike quality of the pastel

a degree of predictability, and transformed the process of using pastel from one of laborious preparation to ready availability. This is not to suggest that all pastels were alike. Carriera corresponded with contacts across Europe asking them to send her the best pastels available in their cities: we know from one such letter that she found some Flemish pastels to be 'the most beautiful shades, but a little too hard' and French pastels 'the best of all'.[10] Liotard must have appreciated the celebrated pastels made by Stoupan, in Lausanne, since he appears to have instructed his only pupil to use them.[11] John Singleton Copley (1738–1815), a largely self-taught artist working in Boston, drafted a letter to Liotard in 1762 asking him to send 'a sett [*sic*] of the best Swiss crayons' across the Atlantic.[12]

With this ready supply of crayons came the shift from 'drawings in coloured chalks' to 'painting in pastel'.[13] As had been the practice for centuries, artists continued to use pastels to add touches of colour to preparatory drawings. Well into the 1730s, for example, François Lemoyne (1688–1737) used pastels to depict the floral garlands in his sumptuous study for the head of the goddess Hebe (fig. 22). The goddess is one of the central figures in Lemoyne's monumental *Apotheosis of Hercules*, a vast, vaulted ceiling decoration at the Château de Versailles, which comprises some 142 figures.[14] The range of colours used here and the fineness of Lemoyne's modelling of the flesh tones certainly owe a debt to the explosion of popularity that the pastel medium enjoyed in the first decades of the eighteenth century. But this sheet

clearly remains a drawing, with large swathes of unmarked paper visible, its purpose explicitly preparatory.

Finished pastels, by contrast, behaved like paintings. They were autonomous works of art whose entire surfaces were covered. They hung in frames and on walls, and were not kept in portfolios like drawings were. They were displayed alongside and directly competed with oil paintings. This is not to say that they were not appreciated for their distinctive qualities. Pastels have always been sought after for their soft, velvety appearance – known in the eighteenth century as *fleur* – which comes about as the myriad particles of pastel reflect light diffusely. The uneven surface of a pastel, as can be seen beneath a microscope (fig. 23), scatters light in different directions, 'conferring on pastel an unmistakable matte, velvetlike quality'.[15] Patrons were willing to pay high prices for such effects – sometimes higher than those of oil paintings, and in a completely different league from those of drawings[16] – and the accoutrements required by pastel were also costly. Set in gilded frames behind glinting glass, in rooms filled with other rare, expensive, brilliant objects, pastels were the perfect expression of eighteenth-century taste. And while contemporary sources note a variety of different historical terms to denote the practice – painting with crayons, painting in pastel, painting in crayons[17] – we should think of this as a *painting* practice.

A Pastellist's Tools

We are familiar with the image of a painter at work. We can imagine a figure standing or seated in front of an easel, a palette in one hand, a brush in the other. But what about a painter of pastels, this idiosyncratic technique that shares elements of both painting and drawing? Would a pastellist sit or stand? Would they use an easel or lean a sketchbook on their knee? Where would they place all their crayons? The pastellist's working method is much less familiar. Fortunately, the enormous popularity of the pastel medium in the eighteenth century means that a number of portraits and self portraits of pastellists at work have come down to us, images that provide a great deal of useful information.

Unlike a wet medium, such as oil paint or watercolour, pastels cannot be easily mixed. Once you have made your strokes you can blend pastels together, using a finger or a rolled piece of cardboard known as a stump, but you cannot use a red pastel and a white pastel to make pink. A pastellist therefore required a great many pastels to work with: not only a different pastel for every shade, but for every gradation (light to dark) within that shade. In one portrait of a pastellist at work, Marie Suzanne Giroust (1734–1772) is in front of her easel, a box of pastels in her left hand (fig. 24). This box appears to be an inset from the set of drawers in front of her, and the portrait's painter – her husband, Alexander Roslin (1718–1793) – has taken some artistic licence in painting this rather chaotic, though very appealing, mix of red, green, pink, yellow and blue pastels. In the open drawer to her left we glimpse a much more ordered divider system as discussed in the treatises of the time, which

Fig. 24
Alexander Roslin (1718–1793)
The Artist and his Wife Marie Suzanne Giroust, painting the Portrait of Henrik Wilhelm Peill, 1767
Oil on canvas, 131 × 98.5 cm
Nationalmuseum, Stockholm

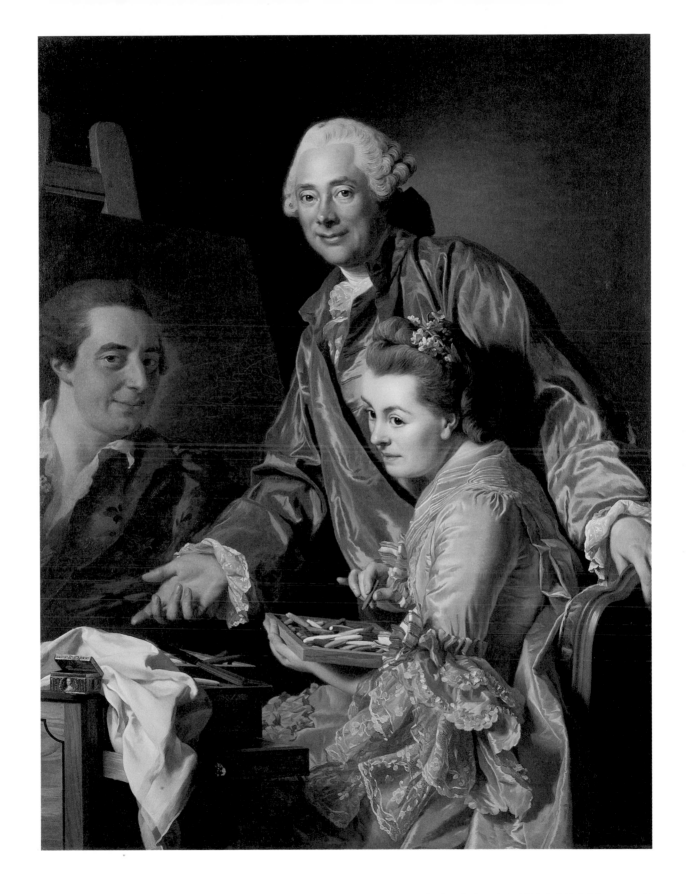

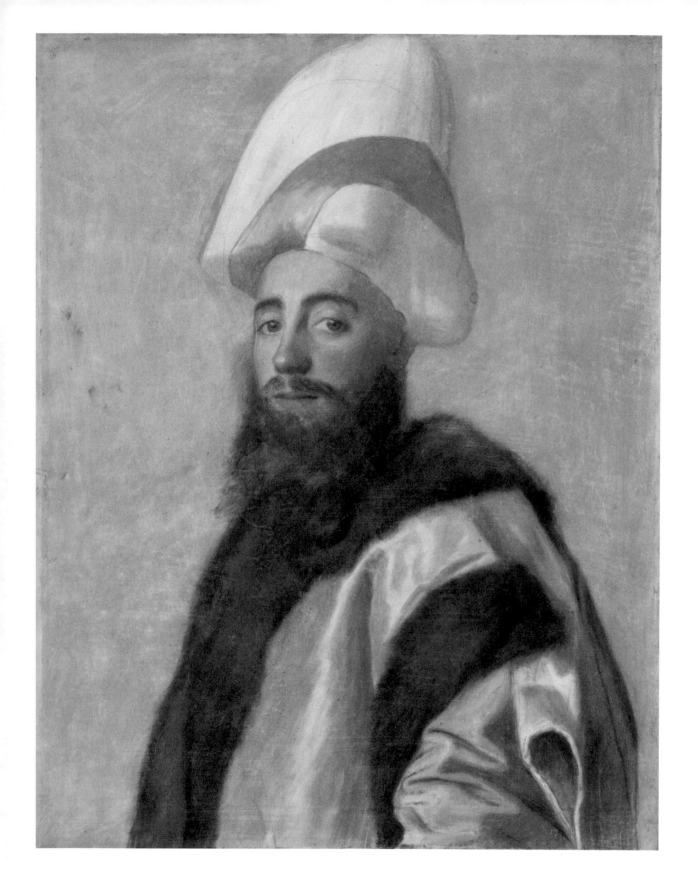

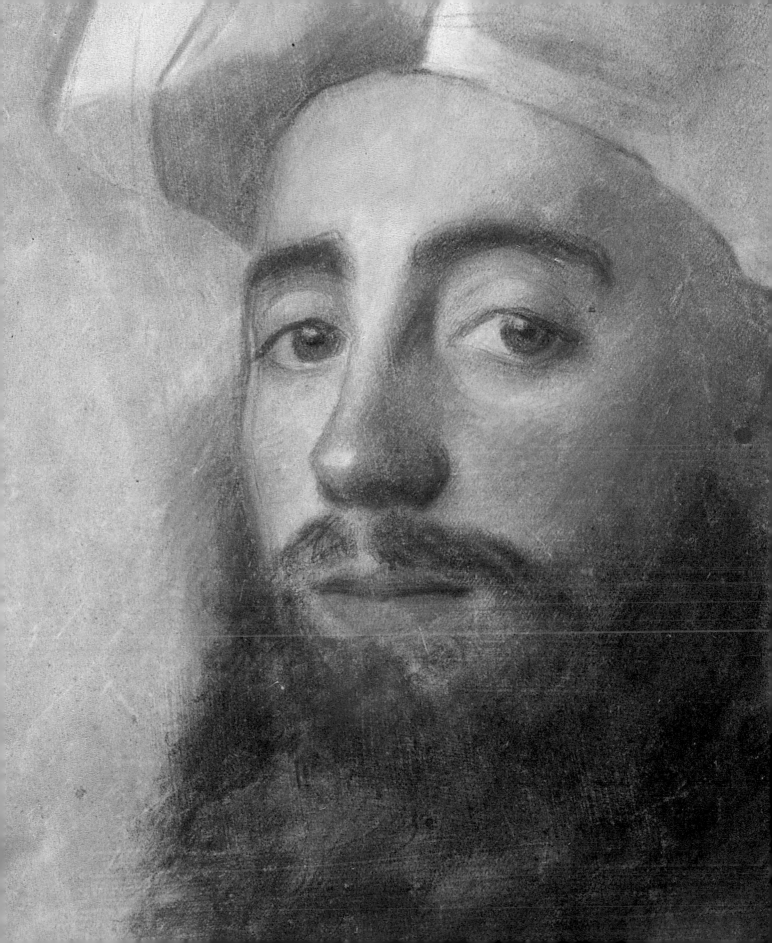

2 mm

recommended two to three wide but shallow drawers in which pastels were to be kept in an orderly fashion and organised by colour.[18]

Once a pastellist had their pastels at their side, they had a choice as to the surface on which they worked (also known as the support). Because it was not a wet material, pastel did not have the chance to dry onto a surface. It therefore required a flat, slightly rough material, this roughness giving the coloured particles something on which to cling. The two most common supports were paper and vellum (prepared animal skin). Vellum had long been used in the production of miniatures and, while more costly, had the advantage of working very well for portraits: in the eighteenth century, there was not a huge difference between the cosmetics used on skin and the placing of pastel on vellum. Paper, though, was the most common choice. This was not smooth, white paper as we think of it today: rather, pastellists preferred the roughest paper possible, made by reducing coarse rags to a pulp and spreading this mix across a wire net. Thanks to the colour of the rags, this paper was often blue (fig. 26). It was felt that the warm flesh tones of a pastel portrait were enhanced by the cool colour beneath. With a microscope, it is possible to see blue rag fibres even on a finished pastel (fig. 27). Artists often chose to roughen both paper and vellum – razors, pumice stones and combs were popular – ready to receive the pastel. A manuscript note among Liotard's papers also describes a complex recipe for making a sort of rough glue that could be brushed over the paper to give it texture.[19]

Almost all pastel portraits in the eighteenth century would have begun with some kind of underdrawing: that is, the marking out of the face and body on the prepared surface. Because of the thick application of pastel on the surface of finished portraits, it is almost always impossible to see this underdrawing with the naked eye. Works that have suffered over time, however, can reveal the drawing beneath. One such example is Liotard's *Portrait of a Grand Vizir* (fig. 25). In this striking work, a man wearing the

Fig. 25 (previous page)
Portrait of a Grand Vizir, or of a European dressed as one, about 1741
Pastel on parchment, 61.6 × 47.6 cm
The National Gallery, London

Fig. 26
Blue rag paper at the Moulin du Verger, 2020

Fig. 27
Photomicrograph of the paper at the right edge of *The Lavergne Family Breakfast* (fig. 1), showing the blue fibres in the paper

ermine-trimmed coat and white turban of the Ottoman grand vizir (prime minister) turns to meet our gaze. His face, with its ruddy cheeks, soft lips and piercing blue eyes, is the best-preserved part of the picture. Many other areas appear to have been significantly abraded: his beard, for example, lacks both volume and definition, while much of his torso is covered in noticeable striations, possibly due to the parchment having been rolled up.[20] Although the current thinness of the pastel is lamentable, it tells us a great deal about how Liotard constructed his portraits. We can easily see where he has drawn and redrawn the contour of the sitter's right cheek; how he has marked out the sitter's eyes, nose and brows; and that the conical turban was initially much less tall. Whether as a result of being damaged or being left unfinished, this enigmatic portrait, whose sitter has yet to be securely identified,[21] offers a valuable glimpse into the pastellist's working practices.

It was common for artists to join multiple sheets of paper together to get the size of surface they desired. We can see one such join in Liotard's *Self Portrait with a Long Beard* (see fig. 4), where a fictive, painted join runs horizontally along the blue sheet on which he is working. This fictive join, about three-quarters of the way up the pastel-within-a-pastel, comes into very close proximity with a real paper join, which runs vertically down the right-hand side of the picture, adding a few centimetres onto the self portrait's width. Liotard himself joined at least six sheets of paper together to paint *The Lavergne Family Breakfast* (see fig. 1), while one of the largest pastels painted in the eighteenth century, Maurice-Quentin de La Tour's *Portrait of Gabriel Bernard de Rieux* (see fig. 20), comprises a staggering 16 sheets of paper. This paper would have been wetted and stretched over canvas, itself stretched over a simple wooden frame (a 'strainer'). As it dried, the paper would become taut enough for the artist to work on. However, even if the paper was stable, works in pastel remained notoriously fragile.

Precious Dust

It is impossible to think about pastel without encountering its fragility. As the distinguished contemporary scholar of pastels Neil Jeffares has noted, 'pastel is no more than dust rubbed into paper'.[22] This is not a new realisation. Pastel's beauty and fragility have long been inextricably linked, as can be seen in this mid-eighteenth-century poem by Claude-Henri Watelet (1718–1786):

Without brush, the finger alone places and blends each tint;
The bed of the paper conserves its imprint,
A glass defends it; as well as beauty
The pastel has brilliance and fragility.[23]

Another eighteenth-century writer, Antoine-Joseph Pernety (1716–1796), went further: 'Painting in *pastel* has great liveliness & a velvetiness that approaches nature much more closely than other types of Painting; but unfortunately it is

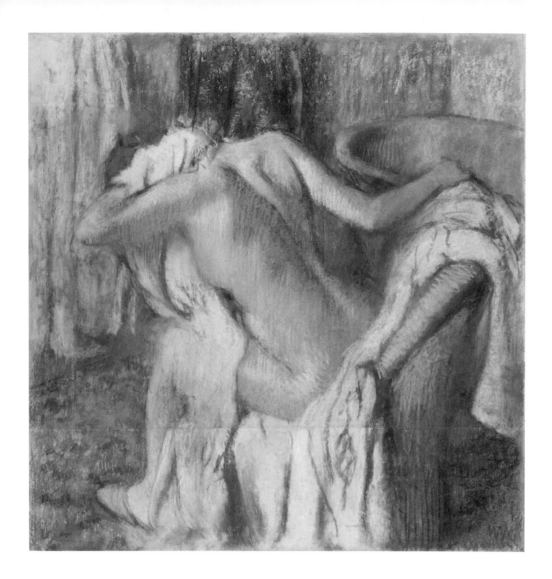

Fig. 28
Hilaire-Germain-Edgar Degas
(1834–1917)
After the Bath, Woman drying herself, about 1890–5
Pastel on paper, mounted on board, 103.5 × 98.5 cm
The National Gallery, London

only dust, that the wind, the breath & the slightest touch can carry off.'[24] Even at the height of its fame, the pastel medium was permeated with impermanence. The great art critic Denis Diderot, who himself sat for several pastels, perhaps best encapsulates the ephemeral nature of pastel in the phrase 'precious dust'.[25]

Diderot captures some of the inherent contradictions of the pastel medium. Pastels commanded huge prices, yet they were essentially made of dust. They were bemoaned for their fragility, yet praised for preserving their colours better than oils, which were known to yellow: in 1747, one writer could note on the same page that the colours of La Tour's pastels would be perfectly preserved for posterity, while acknowledging that many of Carriera's pastels had already been irreversibly damaged.[26] Pastels had a reputation for being easy to work with,[27] yet were also notoriously difficult, for the slightest hint of overworking a pastel could cause the powdery surface to collapse

and be ruined. They were employed by some of the most celebrated artists of their day, but were also the preserve of amateurs, who could buy a box of crayons and try their hand at home. Many of the most acclaimed pastellists of the eighteenth century were men, yet the medium, whose portability and convenience undoubtedly made it more accessible to women artists than oil, was tarred with the brush of femininity. Joshua Reynolds belittled pastel as 'what ladies do when they paint for amusement'.[28] Pastels required framing and glazing at great expense, yet were made using such humble items as 'a bit of hard bread',[29] the recommended tool for rubbing away any pastel that displeased the artist.

Pastel, as we have explored it in this chapter, was a distinctly eighteenth-century phenomenon. A medium of elegance, taste and refinement, it was inextricably linked with the salons and social milieux in which it hung. In France, the French Revolution sounded the death knell for pastel: by the end of the century, it had fallen completely out of fashion. At the Paris Salon of 1751, three artists exhibited two dozen works in pastel, accounting for 17 per cent of the paintings on show. By 1791, when the newly formed Assemblée Nationale rejected the hierarchical structures of the Ancien Régime and decreed that any artist who wanted to could exhibit at the Salon, pastels accounted for just 4 per cent of the works shown. Too strongly associated with the elite spaces

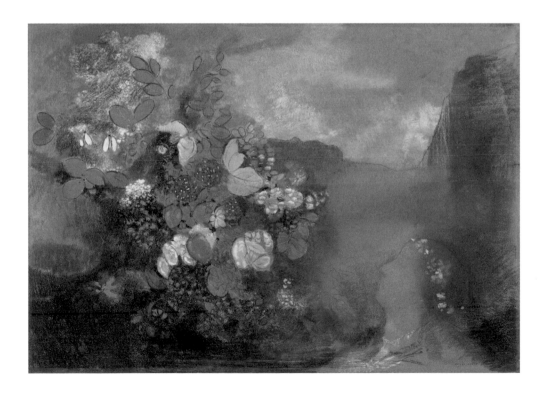

Fig. 29
Odilon Redon (1840–1916)
Ophelia among the Flowers,
about 1905–8
Pastel on paper, 64 × 91 cm
The National Gallery, London

in which it had been admired, the royal and aristocratic likenesses it had traced and the wealth it had depicted, pastel was not the medium with which to represent the new republican France. In other parts of Europe, too, taste turned towards different media. In the early nineteenth century, watercolour would become the medium of choice for many British artists, amateurs and patrons. Although pastel resurfaced again in the late nineteenth century with artists like Degas and Redon, those works are of an entirely different vernacular (figs 28 and 29).

Given how much was written about pastel in the eighteenth century, we know surprisingly little about how these works were painted. Liotard is, today, the artist whose techniques have been studied in greatest depth, although he was far from a typical pastel painter.[30] Yet even this material on Liotard's work pales in comparison to the kinds of studies that have been carried out on oil paintings. In considering how Liotard painted, we have two unusual and useful sources. The first comprises two, almost identical pastel paintings that Liotard made of Princess Karoline Luise von Hesse-Darmstadt (fig. 30 shows one of these). Having travelled with the Habsburg court to Frankfurt for the coronation of Franz Stefan as Holy Roman Emperor in September 1745, Liotard remained several months in Germany and gave Princess Karoline Luise (1723–1783) a series of lessons in how to paint in pastel. We see her here at her easel, her box of pastels at her side, a crayon in her hand, as if about to follow Liotard's instructions and begin a work.[31] Extraordinarily, the second source tells us exactly what these instructions were, for a list of them is preserved, written in the princess's own hand.[32] The advice ranges from blanket statements about technique – 'blend with colours, not your finger', 'do not use green' – to precise guidance about depicting particular things.[33] Half-shadows on the face, for example, should be painted 'in umber, broken up with blue or violet'; the design for lace should be painted in blue, with the edges in white and the holes within the design in dark or black tones.[34] It is an astonishing document – a rare surviving relic of the act of teaching – but it is not a step-by-step guide. It still does not tell us how a pastel was made. As we will see in the next chapter, scientific investigation of pastels can reveal new information, but much of what we know about this medium remains the domain of close looking.

Fig. 30
Karoline Luise von Hesse-Darmstadt, 1745
Pastel on parchment,
62.5 × 48.5 cm
Staatliche Kunsthalle, Karlsruhe

FRANCESCA WHITLUM-COOPER

The Lavergne Family Breakfast

At their breakfast table, an elegantly dressed woman watches a little girl dip
a piece of bread into a cup of milky coffee (fig. 31). We know that it is early
morning as the girl wears paper curlers in her hair. On the table between them
lies a sumptuous still life: a pewter coffee pot, a simple milk jug, a bowl of
sugar and two delicate, beautifully decorated cups and saucers. This still life is
a symphony of reflective surfaces, from the gleam of the pewter and the tiny
window frame reflected in the glaze of the milk jug, to the black lacquer tray on
which the ensemble sits and in whose reflection it is doubled. The objects are
animated by a series of tenderly observed gestures, the fingers of the woman's
right hand curling perfectly around the milk jug's handle, those of her left
reaching out to steady the saucer into whose cup the bread is being dunked.

The Lavergne Family Breakfast is an exceptionally appealing picture – so
appealing, in fact, that Liotard painted it twice. That in itself is not uncommon:
artists (and their assistants) often made versions of important pictures, either
at the request of the patron or to retain in their studio as an example to show
future clients. It was unusual, however, for an artist to return to a work after
almost two decades.[1] Liotard painted The Lavergne Family Breakfast in pastel in
Lyon in the summer of 1754. We can see the inscription confirming these facts
on the sheet of music that pokes out from the table's open drawer: Liotard /
a lion [in Lyon] / 1754 (fig. 32). In London, in 1773, he painted an almost identical
version in oil (fig. 33).

Liotard was justly proud of The Lavergne Family Breakfast. He described it
in his manuscript autobiography as one of his 'principal works' and devoted two
passages of his Traité des principes et des règles de la peinture to the composition.[2]
Several eighteenth-century biographies of Liotard mention the pastel, and

Fig. 31
Detail from The Lavergne Family
Breakfast, 1754 (fig. 1)

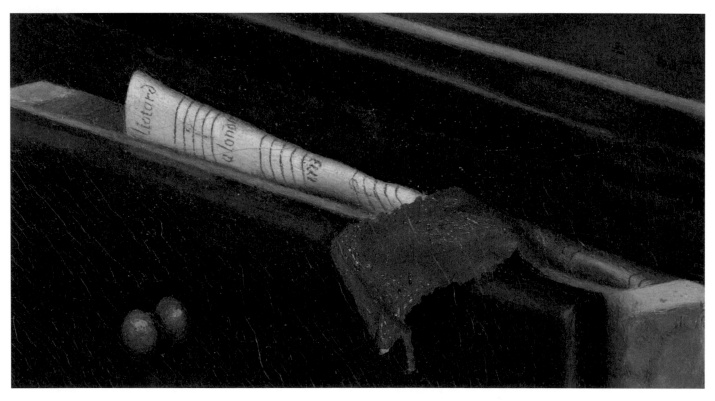

Fig. 32
Detail showing Liotard's signature from *The Lavergne Family Breakfast*, 1754 (fig. 1)

Fig. 33
Detail showing Liotard's signature from *The Lavergne Family Breakfast*, 1773 (fig. 2)

Fig. 34
Sir Everard Fawkener, about 1753–5
Enamel on copper, 7.7 × 6.4 cm
The Ashmolean Museum, University of Oxford

the very high price of 200 guineas at which he sold it – information the artist must have been keen to circulate.[3] The British connoisseur Horace Walpole counted the pastel among Liotard's 'most capital works', and the authors of the artist's *catalogue raisonné* declared it 'Liotard's masterpiece'.[4] Yet for all these accolades, neither the pastel nor the oil version of this composition is well known. Hidden away in British private collections for the past 250 years, they have not been exhibited since Liotard's lifetime and have only very occasionally been published. This essay seeks to give *The Lavergne Family Breakfast* its moment in the spotlight, uncovering who and what it depicts, how it was painted, and what it tells us about Liotard that he returned to the composition 19 years after it was first painted.

Setting the Scene

The story of *The Lavergne Family Breakfast* begins in London. In early 1753, Liotard arrived in Britain for the first time, probably at the invitation of either Viscount Duncannon, with whom he had travelled to Constantinople, or Sir Everard Fawkener, who had been the ambassador in Constantinople during Liotard's stay there. He took rooms in Golden Square at the heart of London's artistic district, was presented (probably by Sir Everard) to the royal family, and quickly became a resounding success.[5] By June, he was said to have 'vast business at 25 guineas a head in crayons'.[6]

A miniature made following Liotard's arrival in London bears witness to the rekindling of these earlier friendships (fig. 34). In this portrait, Sir Everard meets our gaze with a warm, frank expression, his blue eyes bright, his lips perhaps on the verge of smiling. This is an intimate object, to be held in the

hand and admired alongside Sir Everard's own collection of miniatures and gems. The russet-coloured coat and powdered wig evoke the sitter's social status, but not his posting as ambassador in Constantinople, which was alluded to in the costume of his earlier portrait (see fig. 10), or the important role he played, both there and in London, in Liotard's professional career. For it was Sir Everard who had made it possible for Liotard to stay on in Constantinople in 1738, in the period that went on to define the artist's oeuvre and identity, and it was Sir Everard who, upon Liotard's arrival in London in 1753, made key introductions and connections for him.

Renewing his friendship with Sir Everard also led to Liotard's gloriously informal portrait of Harriet, Lady Fawkener (fig. 35). The one a miniature to be held in the hand, the other a large work in pastel, these two Fawkener portraits encapsulate Liotard's technical virtuosity and fluency in very different media. Shown seated in three-quarter-length view, Lady Fawkener looks engagingly towards us. Her right hand searches in the sewing box on the baize-topped table beside her; her left holds a fine thread, perhaps alluding to her husband's successful career trading fabric and silk prior to taking up his diplomatic position. She appears confident and at ease: Liotard has not shied away from her soft, round face (her complexion was said to be of 'the most exquisite brilliancy'[7]) or the ample form beneath her white mousseline dress. Although illegitimate and more than 30 years younger than her husband, Lady Fawkener (about 1726–1777) was fully accepted in and well thought of by London society, and thus precisely the sort of person Liotard sought to paint.

Liotard was 50 when he arrived in London and at the height of his self-presentation as 'the Turkish Painter' (see fig. 11). Among the works that he advertised at his house on Golden Square were 'several other Drawings of Turkish Figures, done from the Life at Constantinople',[8] and part of the attraction of sitting for Liotard in London was evidently the chance to be painted in Turkish dress oneself. We see this in the exquisite portrait of Lady Anne Somerset, where Liotard combines youthful confidence with a flicker of uncertainty (fig. 36). Lady Anne (1741–1763), with her cascading auburn locks and plunging neckline, looks at first glance much older than her 14 years. Yet there is something in her expression that conveys a slight nervousness, the sense of a child presenting herself as an adult for the first time. Her dress, with its sprigs of red flowers and distinctive blue trim, is very close to that in the drawing of the *Woman from Constantinople sitting on a Divan* (see fig. 8), which Liotard brought with him to London, and which he must surely have shown his new clients as an example of the costume in which he could paint them.[9]

Liotard's proficiency at painting textiles and fabrics was undoubtedly part of his appeal, and his London works are exceptionally strong in this regard. The Marchioness of Hartington's blue satin cape, with its sheen, its complex falls and folds, and its fluffy fur trim, is one of his *tours de force* (fig. 37). Again, the sitter meets our gaze, but how much franker and more confident the marchioness's gaze is. She was only 22 or 23 when this was painted: already

Fig. 35
Lady Fawkener, 1754
Pastel on vellum, 73.6 × 58.5 cm
Compton Verney, Warwickshire

Overleaf
Fig. 36
Lady Anne Somerset, later Countess of Northampton, about 1755
Pastel on vellum, 61 × 47 cm
Trustees of the Chatsworth Settlement

Fig. 37
Portrait of Charlotte Boyle, Marchioness of Hartington, about 1754
Pastel on prepared paper, 58 × 48 cm
Trustees of the Chatsworth Settlement

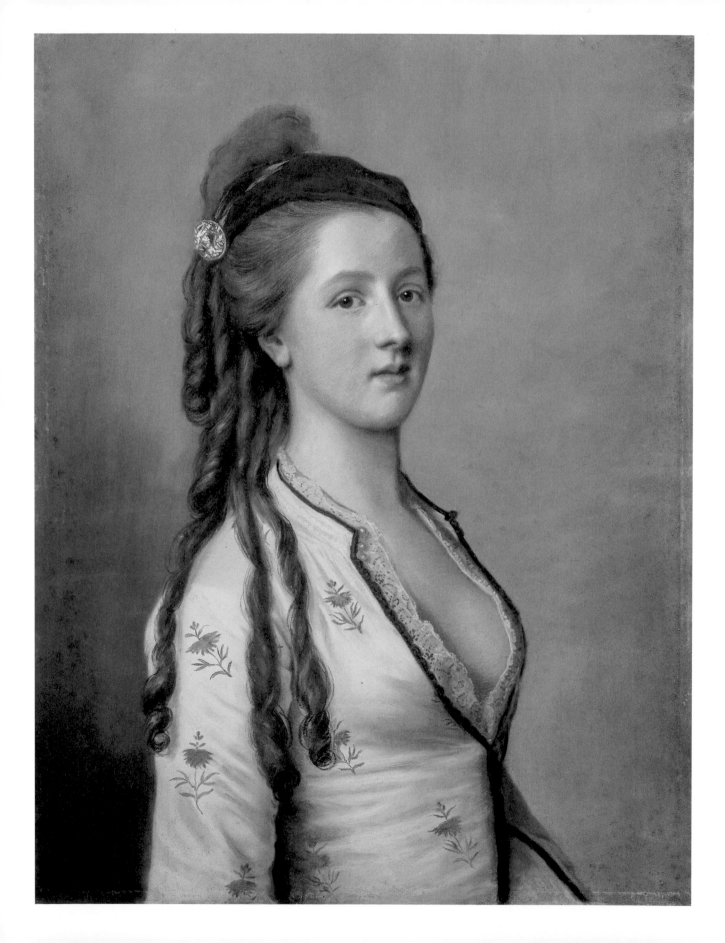

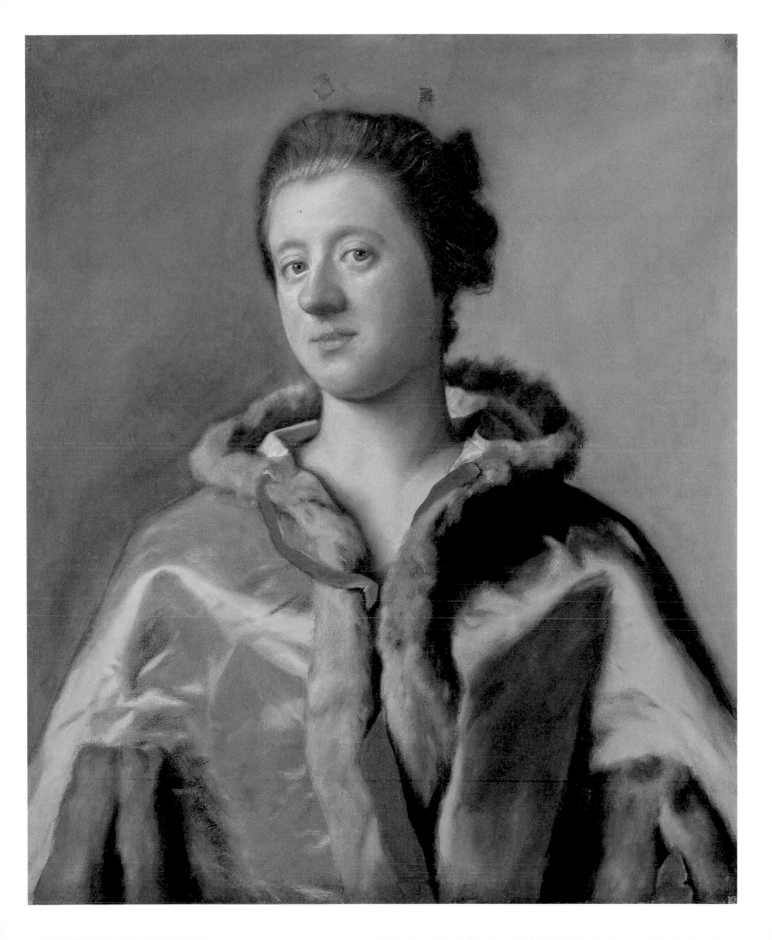

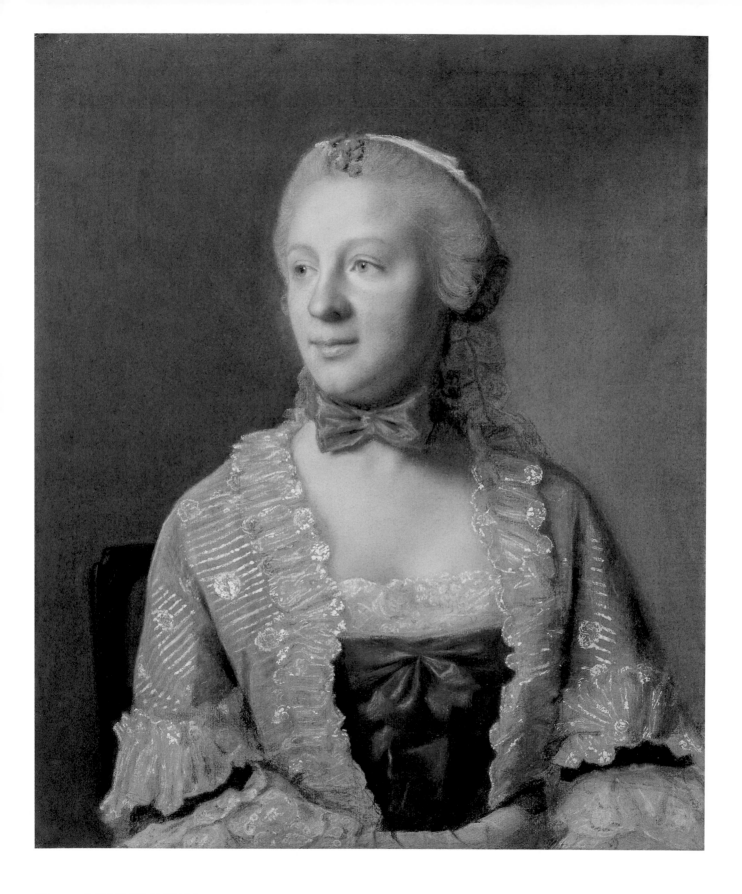

mother to four children, she would die shortly after the picture's completion, having contracted smallpox while pregnant.

Very different handling of both sitter and fabric is found in the portrait of Eva-Marie Garrick (1724–1822; fig. 38), wife of the celebrated actor David Garrick. The couple moved in highly fashionable circles and counted many noble families among their friends, though they were not nobility themselves. Liotard's intimate portrait is the least formal depiction to survive of Mrs Garrick. A symphony in blue and cream, she seems on the verge of turning her head to speak to us. While it would be anachronistic to equate fabric with temperament, the boldness of the swathes of blue satin in the marchioness's portrait seems to match the confidence she exudes, while the much more detailed depiction of Mrs Garrick's lace wrap – painted with passages of impasto like those found in *The Lavergne Family Breakfast* – feels more precise and reserved.

Some fifty finished works survive from Liotard's two years in London in the 1750s, and even a brief survey like the one offered here demonstrates the calibre of clientele he garnered and would continue to garner thanks to this visit. A portrait of George Keppel, 3rd Earl of Albemarle, demonstrates Liotard's enduring appeal among the highest echelons of British society (fig. 39). The earl, who had enjoyed a distinguished military career, is shown in court dress, wearing the bright blue sash and star of the Order of the Garter that he had been awarded in 1762 for the capture of Havana during the Seven Years' War. His portrait is a *tour de force* of Liotard's bold modelling and daringly vibrant palette, and he has clearly relished the challenge of depicting the stiff blue sash, the luxuriant velvet jacket, the gold embroidery, which he has picked out with highlights of wet pastel, and the delicate lace of the sitter's cuff. The earl's radiant face and easy smile belie the poor health that had led him, in 1768, to travel to the South of France and Switzerland in search of a cure. For it was not in London that Liotard painted this British war hero, but in his native Geneva. An inscription on the original backboard of the painting in Liotard's handwriting (fig. 40), unique among his oeuvre, records: 'Milord Count of Albermarle [*sic*] / painted in pastel crayon 1768 by J.E. Liotard / we ask you not to touch the painting / and not to use a Hammer'. This dazzling portrait, parts of which remain unfinished, thus not only shows Liotard at the height of his powers, operating at the highest levels of British society, but it also reminds us of the fragility of his chosen medium and his evident anxiety, in this plea not to use a hammer on or near the picture, about sending a pastel over such a long distance.

In early 1754, Liotard reached 'one of the summits of his art' with the commission from Augusta, Princess of Wales (1719–1772), of pastel portraits of her, her late husband and her nine children.[10] This was an exceptionally important commission. The Princess of Wales – who appears soft, unadorned, curiously informal (fig. 41) – sat for Liotard in February 1754. He received payment 18 months later, in August 1755, having painted her nine children. Private rather than public images, these pastels are extremely intimate, setting their sitters against pale backgrounds, with almost none of the fanfare of their

Fig. 38
Portrait of Eva-Marie Garrick,
about 1754
Pastel on paper, 62 × 47.5 cm
Trustees of the Chatsworth
Settlement

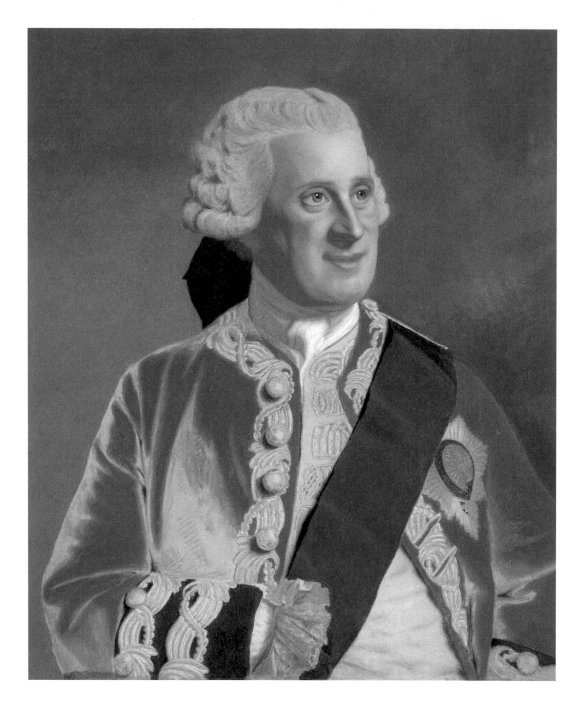

Fig. 39
*George Keppel, Earl of Albemarle
(1724–1772)*, 1768
Pastel on paper, 65.4 × 53.3 cm
Private collection, London

Fig. 40
Inscription in Liotard's handwriting
on the reverse of fig. 39

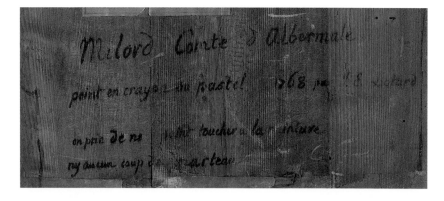

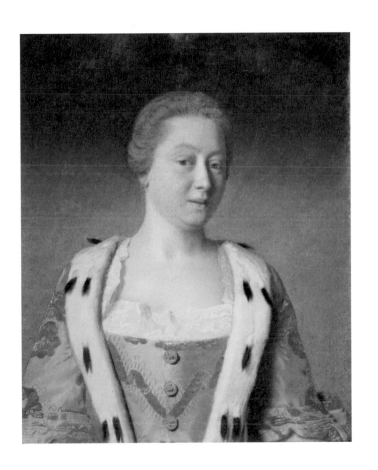

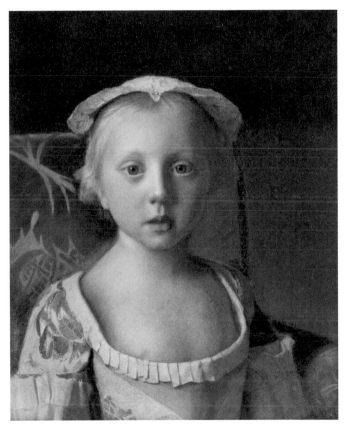

Fig. 41
*Augusta, Princess of Wales
(1719–1772)*, 1754
Pastel on vellum, 64.8 × 51.4 cm
The Royal Collection / HM King
Charles III

Fig. 42
*Princess Louisa Anne
(1749–1768)*, 1754
Pastel on vellum, 40 × 30.5 cm
The Royal Collection / HM King
Charles III

Fig. 43
Advert in the *Public Advertiser*,
13 March 1755

royal status. Some of the portraits are startlingly informal, such as that of Princess Louisa Anne, whose open mouth seems in the middle of addressing us, her dress gaping forward to reveal her nipple, as if to underline that she is a child in too-large clothes (fig. 42). Most peculiar, however, was the fact that Liotard interrupted this royal commission in the summer of 1754 to travel back to family in Lyon.

The Lavergne Family

Liotard left us some helpful clues about this visit to Lyon. Not only did he sign and date *The Lavergne Family Breakfast* with its location – *a lion* – but he also advertised his return to London. In the *Public Advertiser* of 13 March 1755, he placed the following advert (fig. 43):

> MR. LIOTARD gives Notice that he is come back to London, chiefly in order to finish some Portraits he had begun before he went to France last Summer; and therefore does not intend to make here a longer Stay than will be required for that Purpose.
>
> He has brought over a Couple of large Conversation Pictures in Crayons, of his highest finishing.[11]

'[S]ome Portraits he had begun before he went to France' seems a very casual way to reference a commission from the Princess of Wales, but as he did not receive payment for the series until August 1755 these must have been among the works Liotard returned to complete. Among the 'large Conversation Pictures in Crayons' was *The Lavergne Family Breakfast*.

This pastel does indeed represent Liotard's 'highest finishing', both in the sophistication of his forms and in his meticulous attention to detail. From the individual flyaway hairs that have come loose from their hairstyles

(see p. 78) to the pins holding the woman's apron in place (see p. 76), no detail has been spared. Yet for all the attention he gives to painting his figures, Liotard was deliberately lax in denoting who they actually were. Liotard brought *The Lavergne Family Breakfast* back to London as a 'Conversation Piece', a term used to denote a scene picturing figures in a domestic or landscape setting.[12] It was never intended as a portrait, but rather as a generic depiction of a woman and child. This is why, therefore, he sometimes referred to the figures as his 'nieces' and at other times as 'a lady having in front of her a Chinese teaset, and giving a cup of coffee to her daughter', when he knew that the two women were not mother and daughter at all.[13]

In 1713, Liotard's elder sister Sara (1692–1757) had married François Lavergne (1678–1752), a businessman in Geneva who relocated to Lyon with his wife and their 10 children in the early 1730s.[14] An eleventh child would be born in Lyon. Three of Sara's eight daughters had died by the time of Liotard's 1754 visit to Lyon, but Neil Jeffares has convincingly argued that the adult figure depicted in *The Lavergne Family Breakfast* could be one of three of the artist's surviving nieces: Catherine (1723–1757), Marguerite (1727–?1789) or Anne-Andrienne (1728–1768), who would have been about 31, 27 or 26, respectively, when Liotard painted his pastel. The little girl, who looks to be about five or six years old, may be Anne Delessert (1749–1802), the orphaned daughter of Sara's daughter Jeanne (1720–1749).[15] Ten years after *The Lavergne Family Breakfast* was painted we have an account from Jean Jacques Juventin, a Genevan who stayed with the family while passing through Lyon. By his account, they were warm and welcoming – 'so united, so happy, so accommodating' – their daughters the archetype of good and gracious Genevan ladies.[16] Perhaps this is why Liotard made repeated visits.

The Lavergne Family Breakfast was not the only time Liotard made use of his Lyonnais family in his pictures. On the contrary, he seems to have counted on Lyon as a sort of *entrepôt* during his travels: a city in which he could stop, stay with family, and use them as models for pictures to sell elsewhere. He had already done so in 1746 with his niece Anne, known as Marianne, Lavergne (1717–1788), sister of the nieces mentioned above, whose dark hair and greater age would seem to disqualify her from being a sitter in *The Lavergne Family Breakfast* (fig. 44). Liotard carried the genre picture Marianne posed for, known as *La Liseuse* (*The Reader*), with him to Paris and London. He made several later versions of the composition, and was even commissioned by some of his British sitters to paint them in its guise.[17] In late 1754 or early 1755 when he brought *The Lavergne Family Breakfast* to London, Liotard also had with him *L'Ecriture* (*Writing*), for which his nephew, Jacques-Antoine Lavergne (1724–1781), had sat (fig. 45).

The Lavergne Family Breakfast is one of Liotard's largest pastels and arguably his single most impressive work.[18] Having assembled at least six sheets of paper on which to paint it, and having deployed the pastel medium in its traditional dry technique as well as areas of wet impasto, Liotard travelled almost 600 miles

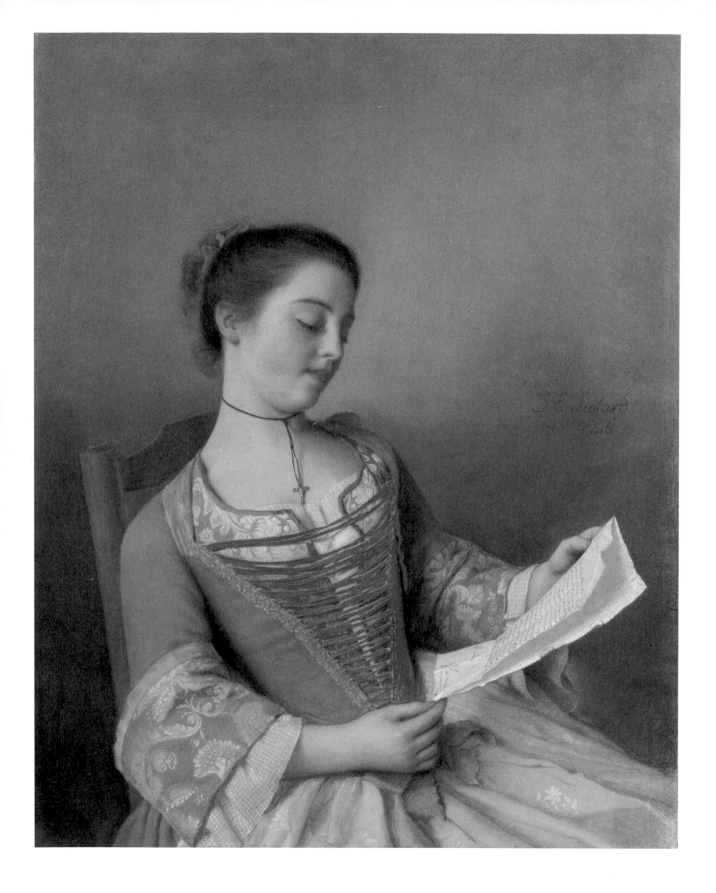

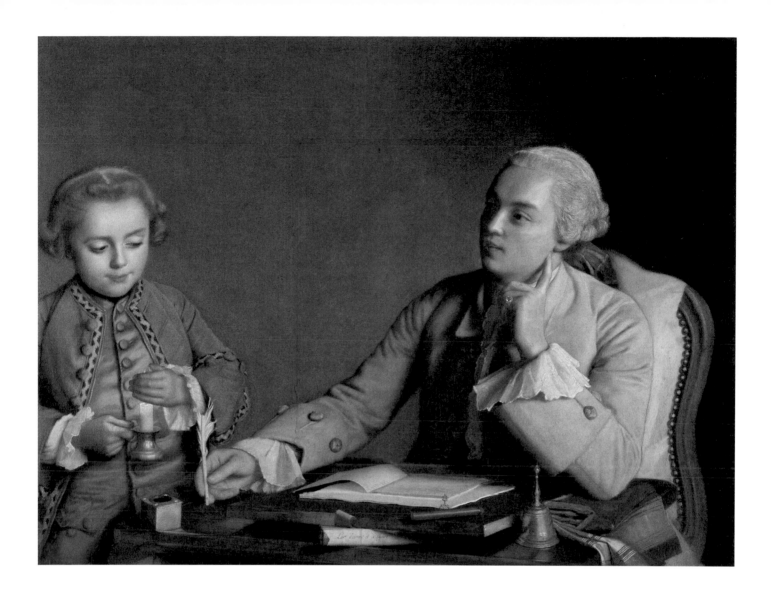

Fig. 44
*The Artist's Niece, Marianne
Lavergne, known as 'La Liseuse'
('The Reader')*, 1746
Pastel on vellum, 54.5 × 43 cm
Rijksmuseum, Amsterdam

Fig. 45
L'Ecriture (Writing), 1752
Pastel on paper, 81 × 107 cm
Vienna KHM

with it from Lyon to London. Miraculously, given the fragility of the medium, *The Lavergne Family Breakfast* reached London intact, and in 1755 Liotard sold it to his old friend Viscount Duncannon for 200 guineas – eight times the price of one of his pastel portraits.

'His highest finishing': Liotard's Technique in *The Lavergne Family Breakfast*

Despite the numerous treatises about pastel painting written in the eighteenth century, the process by which an eighteenth-century pastellist moved from a prepared sheet of paper to a fully finished work remains somewhat obscure. Pastels hide their secrets within them, since most preparatory drawing is likely concealed beneath the final surface. What is more, very few pastels have been the subject of the same level of scientific study as their painted counterparts. But modern imaging techniques can help us shed light on some of Liotard's working practices in *The Lavergne Family Breakfast*, bearing witness to the level of care he took with this work.

Infrared reflectography (IRR) is an imaging technique used to try to 'see through' layers that are opaque in normal light. Here, IRR reveals some of Liotard's preparatory drawing beneath *The Lavergne Family Breakfast*. Underdrawing was found in the faces of both figures, especially around the ears and in the lips of the older woman. It is especially clear in the hands that gather around the girl's cup (fig. 46). Curved lines at the girl's knuckles show how Liotard marked out the different areas of her fingers, while other drawn lines reveal the changes he made to his composition as he worked on it. The cup was initially slightly smaller: the line of the woman's finger shows where it would have gone to reach the rim in its first position. Similarly, the bread was originally about the width of the girl's second and third fingers, before being extended over the line marking the cuff of her dress. The patterns of the backs of the cane chairs, which are depicted in extraordinary soft focus, have been meticulously planned. It is possible to see a grid of fine red lines on top of the pastel (fig. 47): since red pigments become invisible in infrared reflectography, these are distinct from the network of black lines seen in IRR, which Liotard must have used beneath the pastel to create his pattern.[19]

In 1781, Liotard published his *Traité des principes et des règles de la peinture*, a book expounding his beliefs about art. In it, he described the oil version of *The Lavergne Family Breakfast*, then in his own collection in Geneva: 'I dare to flatter myself that in this painting, the different objects have as much relief, volume and vigour as painting is able to give them.'[20] Although he was writing about the oil painting here, which does have obviously built-up areas of impasto, the effect is even more dramatic in the pastel, where thick white pastel has been applied wet and built up to protrude from the paper's surface. This impasto technique is common in oil painting, but rarer in the dry medium of pastel. For Liotard, this 'thick use of colour ... on the pot and on the cafetiere ... better express[es] the gleam of these forms'.[21] Certainly, the use of this white pastel impasto along the hinge and handle of the coffee pot, or the handle of the spoon, brings

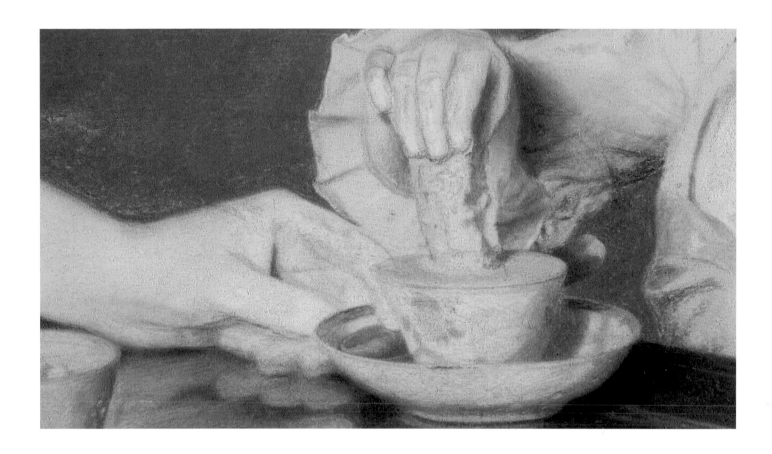

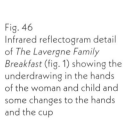

Fig. 46
Infrared reflectogram detail
of *The Lavergne Family
Breakfast* (fig. 1) showing the
underdrawing in the hands
of the woman and child and
some changes to the hands
and the cup

Fig. 47
Photomicrograph of the child's
chair in *The Lavergne Family
Breakfast* (fig. 1), showing part
of the red grid used to make
the weave pattern

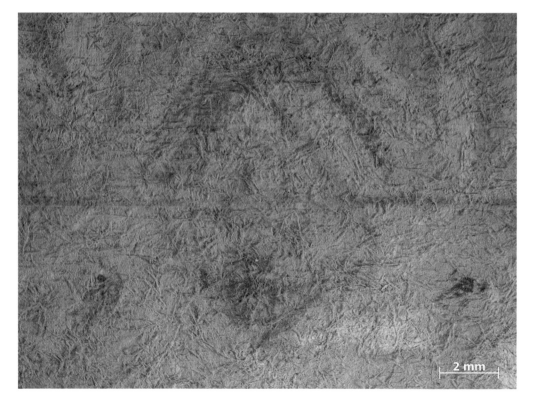

2 mm

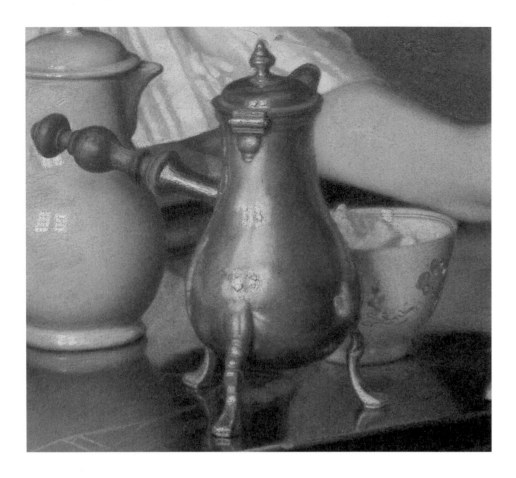

2 mm

Fig. 48
Detail from *The Lavergne Family Breakfast*, 1754 (fig. 1)

Fig. 49
Photomicrograph (in raking light) of the reflection on the silver pot in *The Lavergne Family Breakfast* (fig. 1), showing the thickness of the four highlights

the cool metal surfaces to life, while the individual frames of a window are reflected in the swelling side of the milk pot (fig. 48). High-magnification images taken through a microscope show how much care Liotard went to with these highlights in the pastel: the four highlights above the leg of the coffee pot are built up like miniature landscapes and may have been pressed onto the surface to help them adhere to the paper (fig. 49).

Painting Taste: Tea, Coffee, Chocolate

Although he ended up selling the pastel version of *The Lavergne Family Breakfast* to his greatest patron, Liotard painted the picture speculatively: that is, in the hope rather than the knowledge that someone would buy it. This might seem surprising, given the size and ambition of the composition, but, in some ways, we can see Liotard making a calculated decision with *The Lavergne Family Breakfast*. He had, in 1752, painted *L'Ecriture*, his largest pastel to date, and while it was admired, this piece – depicting a man at a writing desk and a young boy lighting his candle (see fig. 45) – had yet to find a buyer. It would not be until 1761, almost a decade after it was painted, that the Empress Maria Theresa of Austria would purchase it. With *The Lavergne Family Breakfast*, Liotard may have been seeking a more immediate result. His choice of sitters and subject matter would certainly suggest so.

Throughout the eighteenth century, paintings of people drinking tea, coffee and chocolate became extremely popular. This was due in no small part to the fact that these luxurious, expensive beverages, which had to traverse half the globe to reach the breakfast table, enjoyed a parallel popularity, and coffee most of all. That there were some 380 coffee vendors in Paris in 1723 and 2,000 on the eve of the French Revolution illustrates the exponential growth in coffee's consumption in France, which was mirrored elsewhere.[22] It may seem strange, today, to think of a six-year-old drinking coffee for breakfast, but it was deemed important in the eighteenth century to cultivate a child's sense of taste. Taste is what Liotard plays on in his composition. There are the literal tastes we are invited to imagine when looking at the painting – the milky coffee, the sweet sugar, the crunch of the bread – and there is metaphorical taste, the refined taste of those depicted in the picture and, by extension, the person who bought it. In choosing to depict a woman and a child drinking coffee, Liotard was deliberately painting an elite activity for an elite audience.

The attention Liotard paid to the still life in *The Lavergne Family Breakfast* is further evidence of the good taste he was seeking to depict. We see here the juxtaposition of everyday objects and extremely refined ones, a practice Liotard probably borrowed from the seventeenth-century Dutch painters he so admired and later collected.[23] The coffee pot on the table is of a standard mid-century design, presumably made of pewter, not silver, since its tones are subtly different from those of the silver spoons. The milk pot is an undecorated, cream-coloured faience-ware, the type of everyday object commonly used across France. The table-top, however, so shiny as to almost appear mirrored,

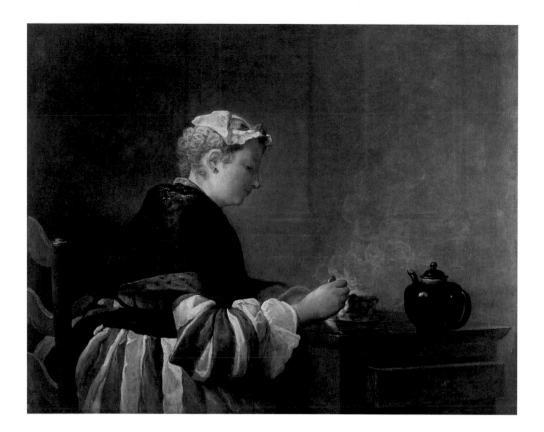

Fig. 50
Jean-Siméon Chardin
(1699–1779)
A Lady taking Tea, 1735
Oil on canvas, 81 × 99 cm
The Hunterian, University
of Glasgow

is black Japanese lacquer, finely decorated with gilded patterns. Such objects were popular in eighteenth-century Europe – we see a red Chinese lacquer table with a similarly open drawer in Chardin's *A Lady taking Tea* of 1735 (fig. 50) – but they were also expensive and desirable. Since it also originated in Asia, had a brilliant sheen and, for eighteenth-century audiences, an almost magical aura to it, lacquer earned the name 'black porcelain'.[24] This extremely refined table-top is intended to tell us something about the figures we see before us. The tea bowls and saucers continue the story.

The cups and saucers in *The Lavergne Family Breakfast* are a study in opposites. One is empty, while the other is so full as to almost overflow, the milky coffee within it a beautiful depiction of surface tension. On one saucer, we see the handle of a teaspoon; on the other, the bowl of the spoon is more prominent. What is perhaps less immediately obvious, however, is the fact that the two cups and saucers, for all the similarity of their bright blue and red designs, do not form a matching pair. For someone so meticulous in his attention to detail, and rigorous in demands to follow nature, this must have been a deliberate decision on Liotard's part.

The cups and saucers we see here are Japanese Imari-ware.[25] They can be identified as such by their distinctive designs, which include red chrysanthemums and jagged blue rocks. Imari was a style of porcelain

originating in Arita, Japan, exported to Europe in large quantities between the mid-seventeenth and early eighteenth centuries by the Dutch East India Company.[26] These designs were later taken up by Chinese porcelain factories, which produced similar wares *en masse* for the European market, but Chinese Imari was less finely decorated than its Japanese counterparts and less fine in its forms. These cups and tea bowls can be identified as Japanese not only because of the gradation of blue tones in the decoration, the obvious thinness of their rims, and the care taken with elements such as the fine hatched border and the scroll on the underside of the saucer, but also by comparing them to a set today in the Porzellansammlung in Dresden (see fig. 61). We know that Europeans could tell the difference between Japanese and Chinese porcelain in the eighteenth century, and that original porcelains were highly prized.[27] Liotard, who, 'like very few other artists … was able to render the different materials and surface qualities that constituted the charm of the novel import goods from Asia', has chosen to paint objects that were not brand new.[28] Rather, being perhaps thirty or even fifty years old and not part of a matching set, they seem to have been chosen for their refinement and rarity, Liotard again implying not only the taste of the people in the picture but also that of its future purchaser.

As we will see in Chapter 4, porcelain, and more specifically the accoutrements for drinking tea, coffee and chocolate, were a lifelong fascination for Liotard. In around 1744, he painted *The Chocolate Girl* (see fig. 58), whose elegant profile and minutely depicted tray of beverages earned the accolade 'the most beautiful pastel that one had ever seen'.[29] In 1752, he painted another breakfast scene (see fig. 66), which he would also sell to a British patron.[30] Following his departure from London, he painted *Dutch Girl at Breakfast*, his love letter to Dutch art (see fig. 59). Although the latter is painted in oil and on a much smaller scale, we nevertheless see the same minutely observed accoutrements of coffee-drinking, the same fascination with reflective surfaces.

Towards the end of his life, Liotard dispensed with the figures altogether, painting a series of still lifes of tea sets without the people drinking from them, the finest of which is today in the J. Paul Getty Museum (fig. 51).[31] If *The Lavergne Family Breakfast* has been called 'a still life with coffee set and two humans in attendance',[32] *Still Life: Tea Set* is the distillation of this impulse. A set of Chinese export porcelain sits somewhat haphazardly on a painted metal tray. With upturned cups, spoons sticking out in every direction and the leftover crusts of bread and butter, it is as if the participants in this lively tea-time ritual have just stepped away from the table. For all the disarray of the composition, however, there is nothing haphazard about Liotard's technique. The painting is characteristically meticulous, a virtuoso performance in illusionism, volume and reflective surfaces, the culmination of a lifetime's fascination with porcelain.

It is impossible, however, to look at these images today without also taking into account that which is not visible. For each cup of chocolate, each cafetière,

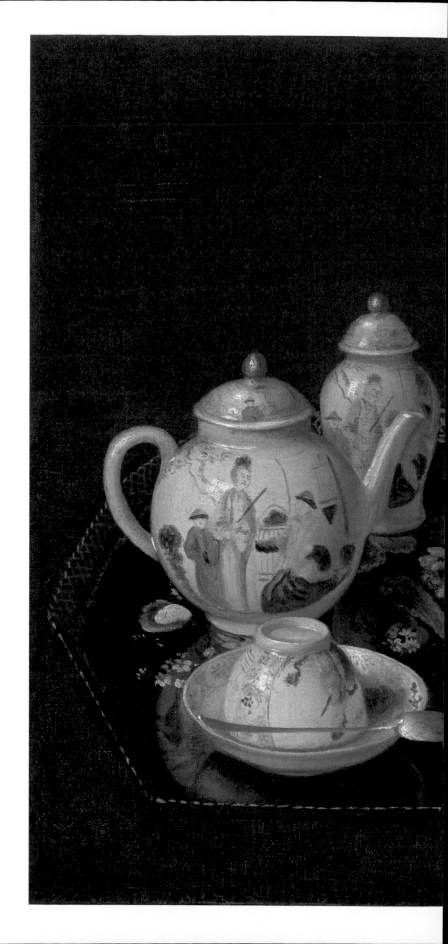

Fig. 51
Still Life: Tea Set, about 1781–3
Oil on canvas mounted on
board, 37.8 × 51.6 cm
The J. Paul Getty Museum,
Los Angeles

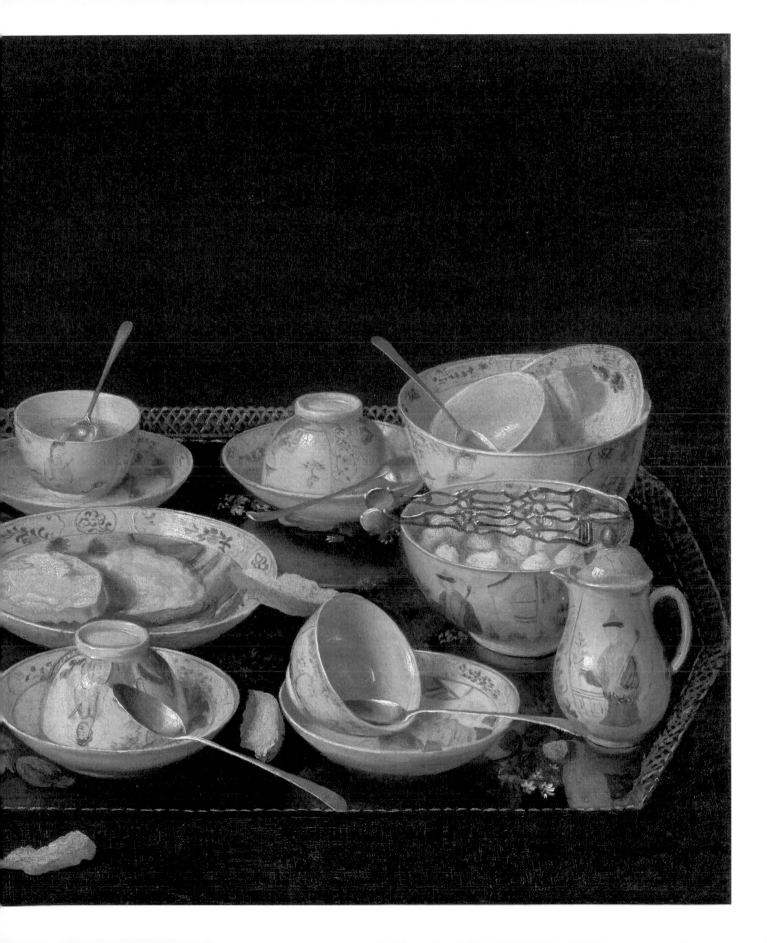

each bowl of sugar, each piece of Japanese porcelain, there was a whole world of global trade connections behind it; in the case of the chocolate, coffee and sugar, one reliant on the traffic of human beings. In 1769, the French writer Jacques-Henri Bernardin de Saint-Pierre noted:

> These beautiful pink and red colours in which our women dress themselves; the cotton with which they pad their skirts; the sugar, the coffee, the chocolate they have for breakfast, the rouge with which they relieve their paleness: the hands of miserable Black people have prepared all of this for them.[33]

Eighteenth-century consumers would have been aware of these connections. For all that Liotard's works attract a vocabulary of luminosity and brilliance, the reality behind his choice of subject matter was far darker.

Returning to *The Lavergne Family Breakfast*

It was not clear, when Liotard left London in 1755, whether he expected to see *The Lavergne Family Breakfast* again. His stint in the British capital had been extremely profitable, so it was not out of the question that he would return in the future, but given the huge undertaking of such a journey, his marriage relatively soon after departing, and the uncertainty of eighteenth-century life in general, it cannot have been a given for him that he would see this most highly prized work again. *The Lavergne Family Breakfast*, however, certainly lingered long in Liotard's imagination. He mentioned it in his autobiography in 1760, and this mention was taken up in many contemporary biographies of the artist.[34] In late 1772, Liotard returned to London. In 1773, he returned to his painting.

By the time of this second visit, Liotard was 70 years old. He had long since shaved off the beard that had caused him such great renown, and the celebrity that he had enjoyed in the 1750s had diminished somewhat over the subsequent decades. The London art world to which he returned had also changed. The Royal Academy had been founded; there was now a more established British school to speak of, and an institution celebrating that school and training its next generation of artists. Certainly, in the case of pastel, there were other figures, such as John Russell (1745–1806), now working in Liotard's preferred medium. If Liotard found more competition in London second time around and consequently fewer commissions, it may go some way to explaining why he chose to return to the familiar territory of a previous composition and to make a copy of *The Lavergne Family Breakfast* in oil.

The oil version of *The Lavergne Family Breakfast* measures 81.4 × 103 cm (see fig. 2). When the two compositions are overlaid, the figures, chairs and still life are almost identical (fig. 52). Liotard must have used a tracing to duplicate his design, as he had done earlier in his career with *The Chocolate Girl* (see fig. 58). An ink drawing in Geneva, executed across four sheets of paper, offers a life-size reproduction of the figure from this celebrated composition (fig. 53).

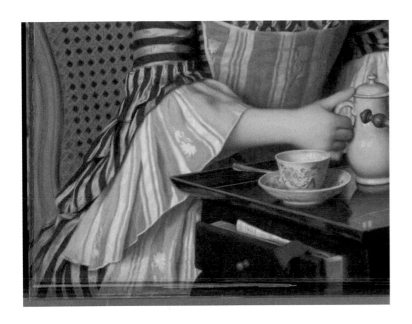

Fig. 52
Detail from an image showing the oil version of *The Lavergne Family Breakfast* (opacity reduced to 50%; fig. 2) laid over the pastel version (opacity 100%; fig. 1). The tracing is so precise that the overlay is revealed only by the woman's dress extending slightly lower in the oil painting, the signatures on the sheet of music and the porcelain decoration on the cup: bright blue in the pastel and degraded to brown in the oil painting, here it appears somewhere between the two

Fig. 53
The Chocolate Girl, about 1744
Brown ink on four sheets of paper, 83.8 × 58.5 cm
Musée d'art et d'histoire, Ville de Genève

As the drawing shows no physical signs of being used as a preparatory sketch, and as it remained in Liotard's family until it entered the museum in Geneva, it is most likely a tracing made from the pastel, perhaps with a view to making a future replica of it. While no such drawing survives for *The Lavergne Family Breakfast*, the closeness between the two versions makes the differences between them all the more interesting. There are two significant changes between the two versions. The first is that the bright blue decorations of the Imari porcelain have, in the oil, turned brown. This is probably the effect of smalt, a blue pigment that often loses its colour. Liotard clearly intended the decorations to match the bright blue of the pastel, as their reflections in the lacquer table, particularly those of the sugar bowl, are still blue (likely the result of having used a different pigment). The second change is that of the signature on the sheet of music, which now reads *Liotard* / *a londres* [in London] / *1773*.

There are other, more subtle differences, such as the greater amount of space left above the figures in the oil painting, but what is extraordinary about this oil is how closely it emulates the pastel. It is not merely a repetition of the composition: rather, it reads almost as an oil *imitating* a pastel. Every fold of fabric is replicated; every stroke of light and dark paint to create the reflective sheen of the woman's dress mimics that of the pastel. But

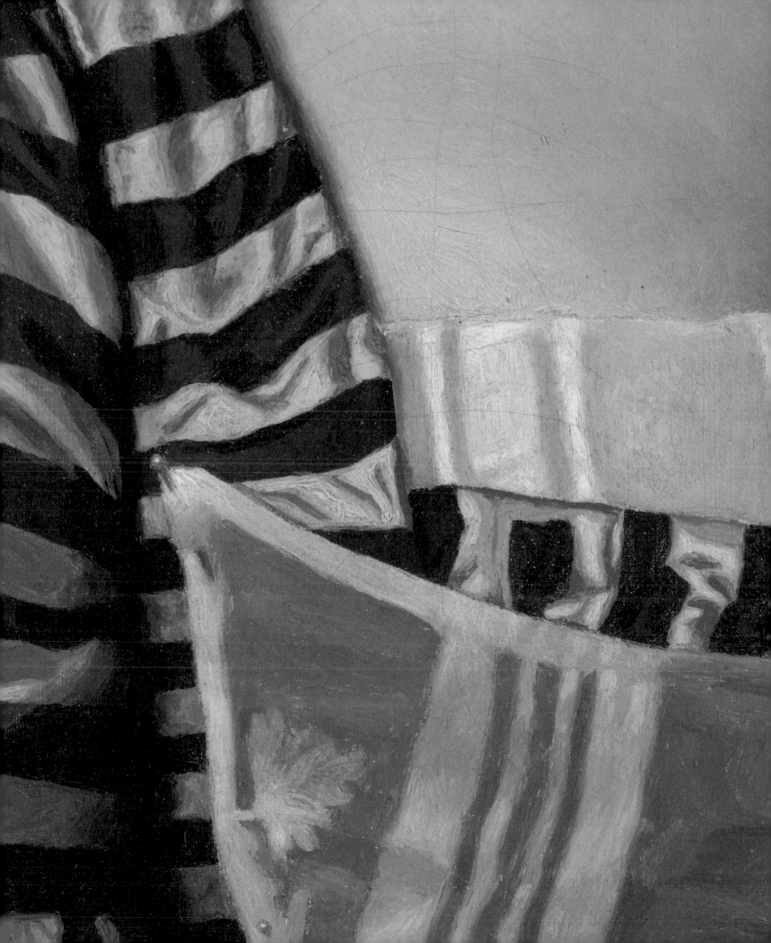

where Liotard could drag the side of his pastel across the surface to create a mid-tone between the pale pink and the red of the shadow (p. 76), for example, in oil he has to use three different tones: dark, medium and light (p. 77). Perhaps most interesting are the moments when Liotard has acknowledged the difference between the two media by using reverse techniques to achieve the same effect. This can be seen in the wispy, flyaway hairs around the two figures' heads. In this pastel, these hairs are drawn with a very fine, sharpened chalk on top of the background (p. 78). In the oil, he leaves an unpainted reserve around the figures' heads that he only partly fills to create the same impression (p. 79). The hair itself is of a far more uniform colour in the oil, while looking closely at the pastel it is possible to see strokes of pink, blue, taupe and grey tones.

Pastel has long been associated with softness. This is certainly true in this comparison. The pastel medium brings a smooth, velvety quality to the flesh tones and fabrics. The picture appears warmer; the figures are animated by the *fleur,* which results in pastel's diffuse reflection of light and which eighteenth-century viewers so prized.[35] One could say, by contrast, that the oil has the upper hand with the smooth reflective surfaces. As an inherently shiny medium, whose pigment is suspended in and seen through the clear, glossy oil, it is perfectly suited to depict the slick black lacquer. The pink dress fabric is paler in the oil, contributing to the painting's overall sense of coolness: this may be the result of a slight shift in the oil paint's colour over time, while the pastel has retained its original colour. Yet the girl's yellow dress seems better preserved in oil (fig. 55), as some of the details that gave volume to its folds in the pastel version appear to have faded (fig. 54).

If Liotard sought to make money from this repetition of *The Lavergne Family Breakfast*, he did not succeed. He placed the picture in a sale of his works with Christie's on 15 April 1774 – 'A lady and her daughter drinking coffee' – but it did not sell.[36] A letter sent from Liotard's son to his mother in 1778 implies that Liotard had taken the picture with him on his final visit to Vienna, but he had again failed to sell it.[37] It was included in a list of paintings Liotard offered to sell to the French royal collections in 1785, which were refused with some extremely derogatory comments.[38] The painting would in fact remain with Liotard's descendants for a century, until 1873. This must have been a blow, since it took much longer to make a copy than an original: on 10 December 1777, Liotard wrote to his wife that the copy he was making of his earlier portrait of Madame Necker 'will take me a lot of time'.[39] However, 1773 was far from the end of Liotard's career. He would go on painting – and experimenting (see figs 16 and 17) – for another 15 years. But this second visit to London marked a turning point. In his seventies, he was no longer the celebrity he had been in his forties and fifties. Pastel, as we have seen in Chapter 2, was no longer the heady medium it had been in the 1750s. Not even Viscount Duncannon, by this point the 2nd Earl of Bessborough and a man who owned more than a dozen works by Liotard, was loyal enough to buy the same composition twice.

Fig. 54
Detail from *The Lavergne Family Breakfast*, 1754 (fig. 1)

Fig. 55
Detail from *The Lavergne Family Breakfast*, 1773 (fig. 2)

Yet if the second *Lavergne Family Breakfast* was not the golden ticket Liotard had perhaps hoped it to be, it did go on to have an unusual almost-reunion with the pastel that it imitated. By the turn of the twentieth century, the oil was in the collection of James A. de Rothschild at Waddesdon. In 1913, Rothschild married Dorothy Pinto. Five years later, Dorothy's father, Eugene Pinto, purchased the pastel. While there is no evidence that the two works were ever placed together then – nor, indeed, that anyone other than Liotard and Bessborough and a handful of others would have seen them together when the oil was completed in 1773 – they did belong to the same (extended) family for the first half of the twentieth century. Now they are reunited here for the first time since Liotard and his most loyal patron looked at them 250 years ago, we are able to experience the same pleasure, the same close looking at medium and material, and the same wonder at this most highly finished of Liotard's pictures.

IRIS MOON

Of Pastels and Porcelain

Porcelain cups are located at the centre of *The Lavergne Family Breakfast*, Jean-Etienne Liotard's intimate portrayal of a woman and girl commencing their day with coffee. In the large pastel from 1754 (see fig. 1), Liotard has rendered the domestic vessels arranged before the two sitters with careful precision. Leaving her own cup empty, the woman has prepared her young companion a cup of coffee (fig. 56). She has just poured milk from the cream-coloured earthenware jug in her right hand, still applying gentle pressure to the lid with her thumb. Next to the milk jug rests the pewter pot with a wooden side handle and tripod feet in which the coffee was boiled; behind it is a sugar bowl, its silver-mounted lid pitched at the edge of the lacquer tray table. The girl, barely awake with paper curlers still in her hair, dips a crust of bread into the milky brew with her eyes half closed. Though steadied by the woman, the contents of the porcelain cup, decorated with blue and red flowers, threaten to spill onto the saucer, offering the only hint of tension in an otherwise quietly composed morning scene. The picture offers an intimate glimpse into the quotidian luxuries of bourgeois domesticity that Liotard took pleasure in depicting as the subjects of his genre-defying pictures, particularly porcelain. This prized, artificial medium, first imported from China, reflected the artist's keen interest in the objects of foreign cultures. Moreover, he sought to capture the unique visual effects of porcelain in his pastels and oil paintings.

When Liotard was born in Geneva in 1702, Europe had not yet successfully managed to produce 'true' porcelain, a ceramic body first made in China that included kaolin as a key ingredient in firing clay at a high temperature to create a sonorous, translucent and durable white body. Early examples

Fig. 56
Detail from *The Lavergne Family Breakfast*, 1754 (fig. 1)

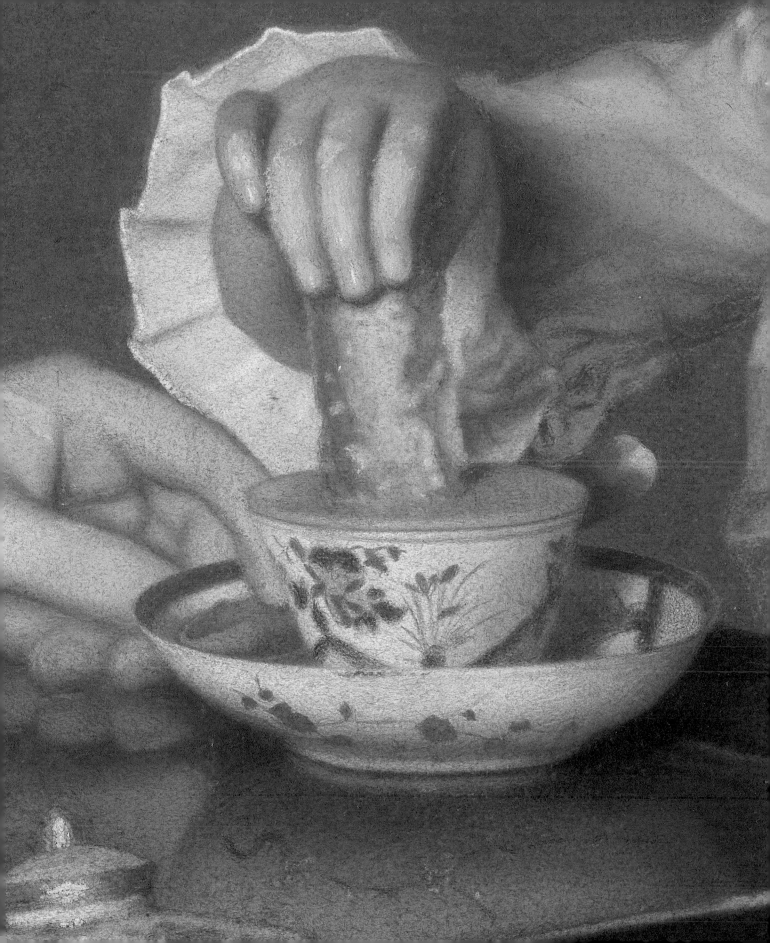

Fig. 57
Maid serving Tea, about 1740–2
Red and black chalk over pencil
on two sheets of paper,
20.5 × 28.5cm
Museum Oskar Reinhart,
Winterthur

of porcelain that arrived in Europe in the sixteenth century prior to the establishment of trade routes were typically blue and white, later encased in elaborate silver and gilded mounts to designate their precious status. Though the establishment of Dutch, Portuguese and English trade routes brought larger quantities of porcelain objects to the European market over the course of the seventeenth century, European rulers had sought to discover the arcanum for true porcelain as early as the Renaissance. Augustus the Strong, Elector of Saxony (1670–1733), established the first successful manufactory at Meissen in 1710, where the recipe, developed by the alchemist Johann Friedrich Böttger (1682–1719), was a jealously guarded state secret that others sought to steal.[1] Early European porcelain closely copied Chinese and Japanese works. Initially considered rare and only for the wealthiest of patrons, porcelain for domestic use became more affordable for upper-middle-class consumers by the second half of the eighteenth century, as increasing numbers of Europeans enjoyed luxuries such as sugar, tobacco, tea and coffee, the products of colonial and commercial expansion. Porcelain retained strong associations with China, signalled through the decorative motifs described as 'chinoiserie', which pictured China as a distant land of fantasy that had little to do with the geopolitical realities of the Qing Empire.

The cultural associations of porcelain with a fantasy of China would have immediately appealed to Liotard, an inveterate traveller who dressed in foreign costumes and called himself the 'Turkish Painter' (see fig. 11).[2] In 1738, he travelled to the Ottoman Empire with John Montagu, 4th Earl of Sandwich, and William Ponsonby, later 2nd Earl of Bessborough, the latter of whom would eventually purchase *The Lavergne Family Breakfast* for 200 guineas. Porcelain objects appear in several works made after Liotard's time in Constantinople, in compositions that show women serving or sipping hot beverages. A red chalk drawing dating to around 1740–2 shows a woman dressed in Ottoman costume seated on a divan holding a small porcelain teacup, from which she sips her tea, while a servant stands nearby holding a tray with a metal *semavar*, or teapot (fig. 57). The subject of young women with hot beverages set in 'exotic' interiors carried connotations of sexual availability, which played into Europeans' Orientalist fantasies at the time. However, Liotard's other portrayals of female domestic servants and porcelain have a more meditative quality, particularly his most famous composition, *The Chocolate Girl* (about 1744). Scrubbed of the ornate interiors from his Constantinople-period works, the pastel depicts a female servant in a starched white apron and fichu scarf (fig. 58). She holds a tray with a cup of water and a Meissen porcelain cup decorated with Japanese Kakiemon floral motifs, set into a *trembleuse*, a saucer with a raised silver holder in the centre meant to help keep the cup stable. Even more meditative is *Dutch Girl at Breakfast* (about 1756). In a tidy interior, a young woman prepares a tray, pouring hot water from a coffee urn in quiet anticipation (fig. 59). The two porcelain cups and saucers suggest that she has company.

Fig. 58
The Chocolate Girl, about 1744
Pastel on parchment,
82.5 × 52.5 cm
Gemäldegalerie Alte Meister,
Staatliche Kunstsammlungen
Dresden

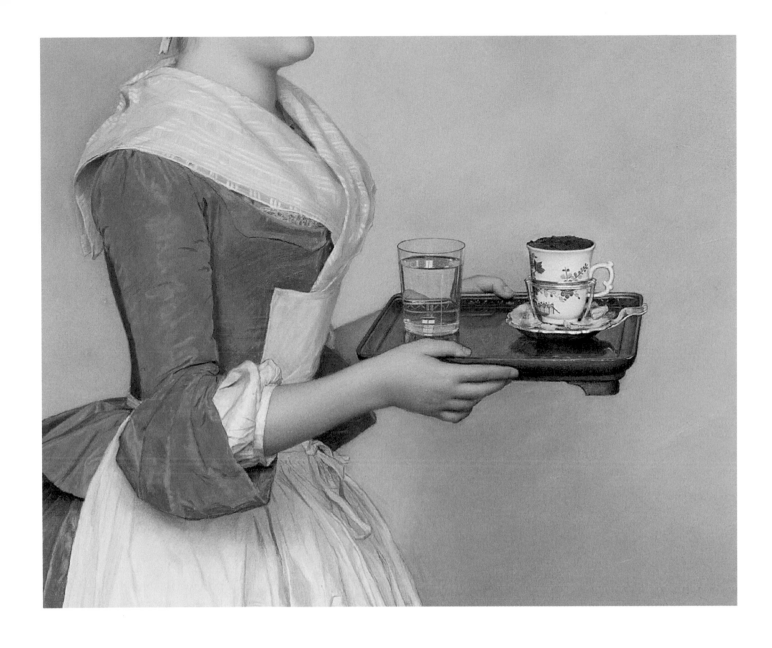

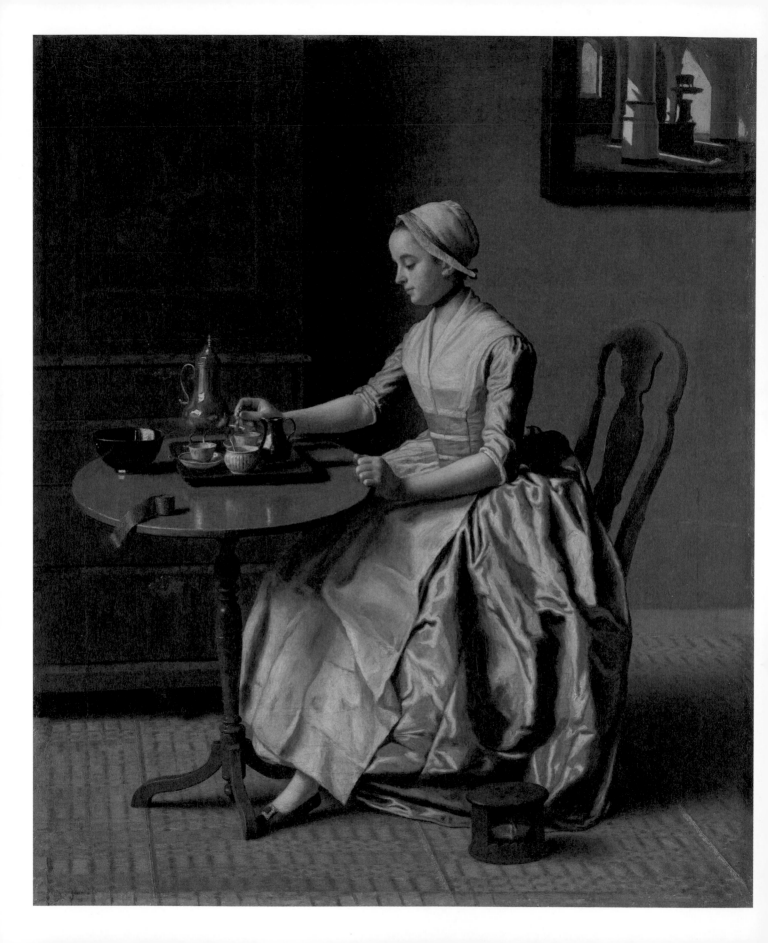

From coffee urns and lacquer trays to cups *à la trembleuse*, the wares rendered by Liotard reveal the wide variety of specialised vessels for hot beverages then available on the European market. These objects catered to the growing demand for coffee, tea and chocolate, increasingly viewed as daily necessities. The day began and ended with them. One might wake up with a cup of chocolate and the morning toilette, while the doors to coffee houses remained open deep into the night, at least for male patrons. At first glance, it is unclear whether the dainty cup set before the little girl in *The Lavergne Family Breakfast* is chocolate or coffee. Both were mixed with milk and sugar, a practice introduced by Europeans although cocoa and coffee were known in the Americas and the Middle East much earlier.[3] In Europe, coffee gained an association as a Protestant beverage, which fuelled the legendary work ethic, while chocolate retained links to the Catholic kingdoms of France and Spain.[4] In terms of vessels, chocolate and coffee pots from the period both tend to have higher profiles than stouter teapots. All three were heated in metal vessels first. Chocolate produced the thickest consistency, requiring a *moulinet*, a type of stirring device inserted into an opening at the top of the pot, which was used to break up the chocolate while heated over a flame. A *moulinet* is seen sticking out of the chocolate pot included in the travel set, or *nécessaire*, offered to France's Queen Marie Leczinska (1703–1768) in 1729/30 (fig. 60). Careful observation of *The Lavergne Family Breakfast* indicates that they are drinking coffee, since the *moulinet* is nowhere in sight. The artist would clarify in his 1781 painting treatise that the pair were in fact drinking coffee, describing the pastel as a woman giving a cup of coffee to her daughter.

The glossy, ornamented surface of the porcelain cups in the composition form a contrast to the luminous skin tones of his sitters. One of the cups bears a striking resemblance to an example in Dresden (figs 61 and 62).[5] An Imari-type Hizen ware, the cup is decorated with rocks and flowers in underglaze cobalt blue and iron red with gilding, and dates to around 1720.[6] The decorative motifs are nearly identical with the cup on the left of Liotard's picture, particularly the distinctive band of hatched marks on the inner rim. The different types of porcelain decoration seen on each of the vessels in the pastel is not surprising, since *marchands-merciers* or luxury merchants often combined different pieces into sets, even distinguished ones such as that belonging to Marie Leczinska (fig. 60). Given that the teacup decorations date to the earlier part of the century, they were perhaps meant to signal outmoded albeit treasured family possessions that had been passed down from an earlier generation. The actual porcelain may have belonged to the artist, though it is also possible that they belonged to his extended family in Lyon who posed for the painting. The inventory taken of his residence on the rue Saint-Antoine in Geneva after his death in 1789 suggested the comfortable circumstances in which he lived. It included, alongside '50 sheets, 40 dozen napkins, 50 tablecloths, 8 dozen hand towels', 'lots of porcelain'.[7] The artist possessed distinguished forms of porcelain, including a gift from one of his

Fig. 59 (and overleaf)
Dutch Girl at Breakfast,
about 1756
Oil on canvas, 46.8 × 39 cm
Rijksmuseum, Amsterdam

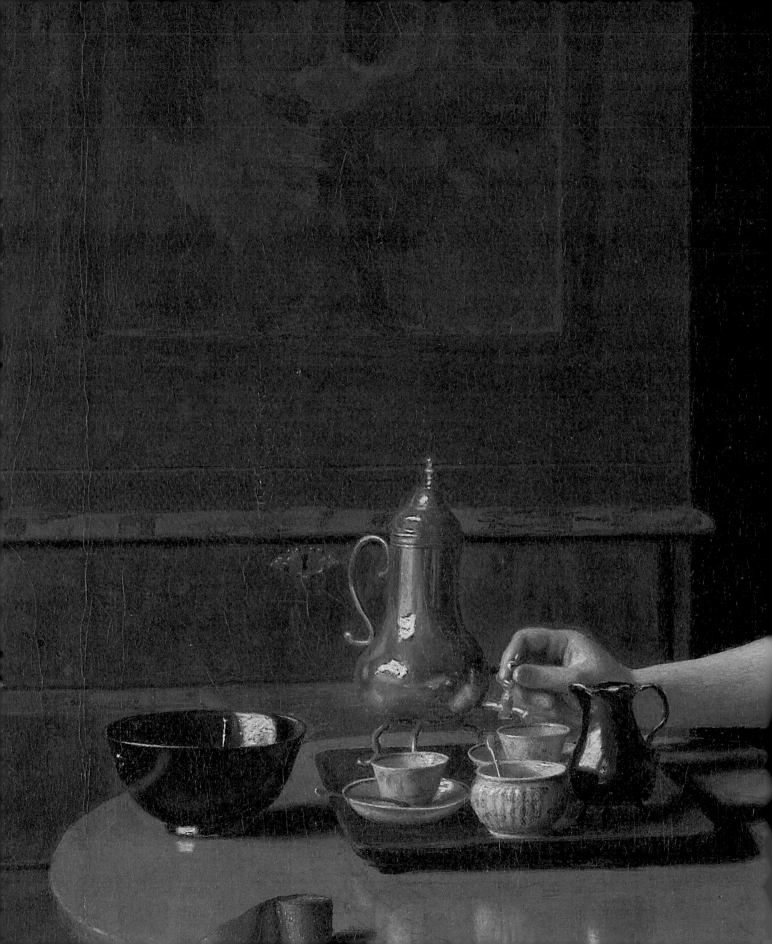

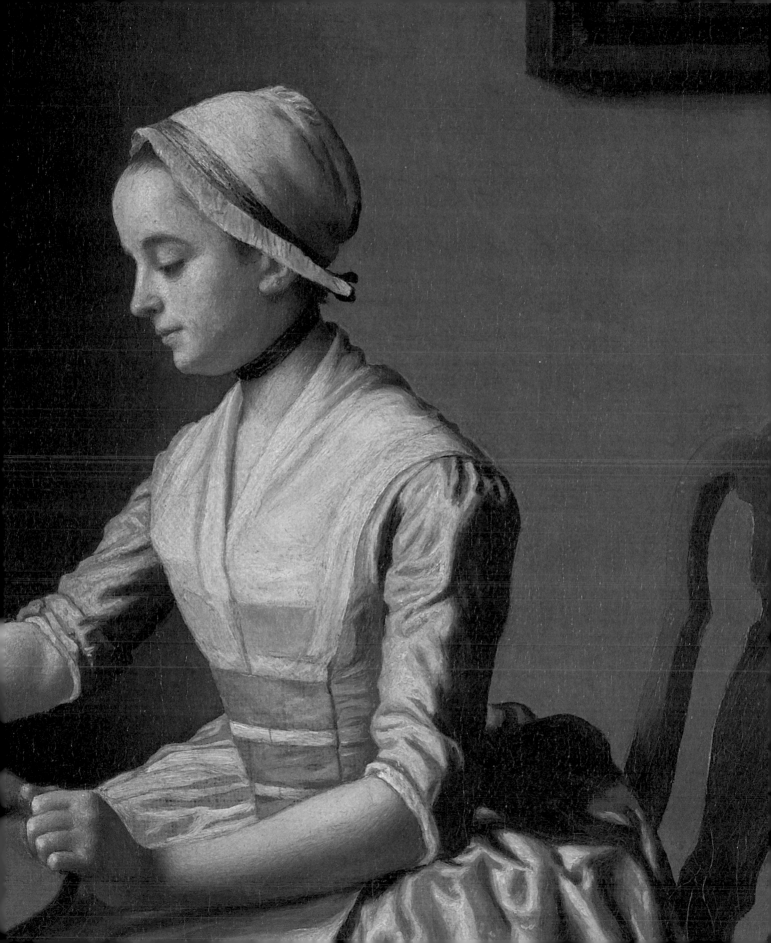

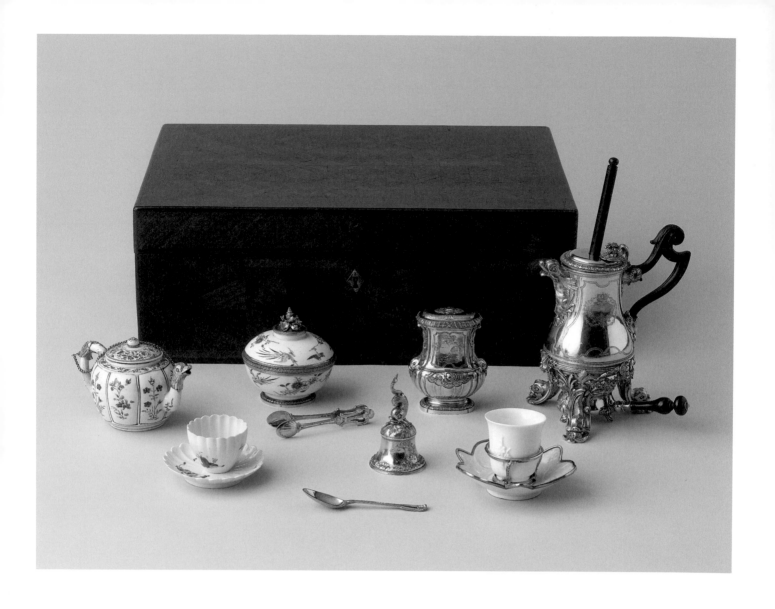

Fig. 60
Henri-Nicolas Cousinet
(1706–1768)
Nécessaire (28 pieces) offered
to Marie Leczinska, 1729–30
Gold-plated silver, gilding,
hard-paste porcelain, rosewood,
ebony, 21 × 56 × 44 cm
Musée du Louvre, Paris

Fig. 61
Japanese Imari-ware cup and
saucer, about 1690–1720
Porcelain, cup: 4.5 × 7.8 cm;
saucer: 2.2 × 12.3 cm
Staatliche Kunstammlungen
Dresden, Porzellansammlung

Fig. 62
Detail from *The Lavergne Family
Breakfast*, 1754 (fig. 1)

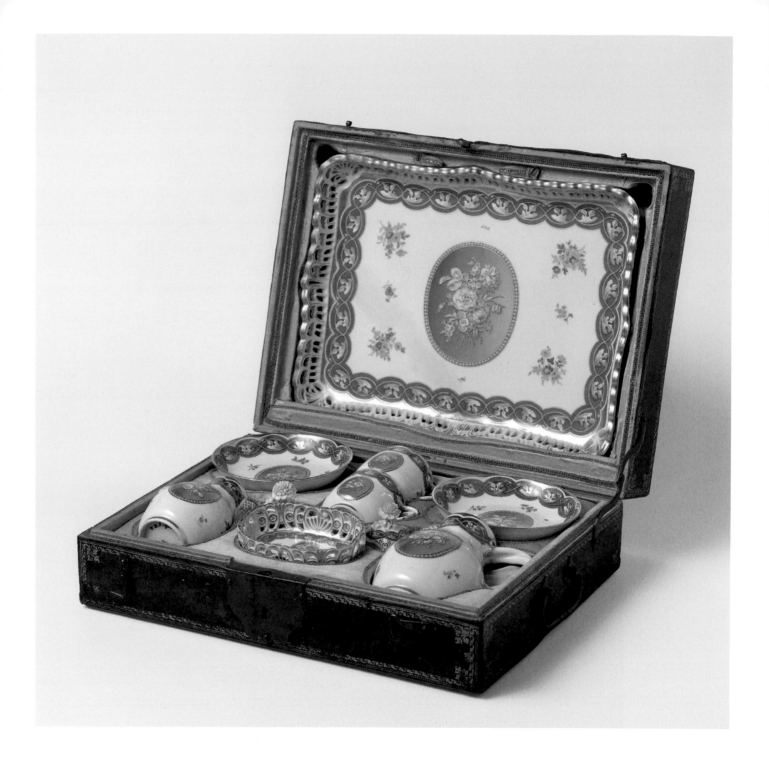

most important patrons, Empress Maria Theresa of Austria, who gave him a porcelain service made at the Vienna Imperial Manufactory, during the time of his last visit to the Habsburg court in 1778 (fig. 63).

Through Empress Maria Theresa, Liotard gained access to the inner workings of the Imperial Porcelain Manufactory in Vienna. Around the time that the artist began working for the empress in 1743, Maria Theresa had purchased the manufactory of Claude Innocentius du Paquier (died 1751) after his imperial privilege had expired. Like other European royalty, the Habsburg ruler saw porcelain production as a means of asserting state power when her own legitimacy as sovereign remained on shaky ground. Although Du Paquier had specialised in producing Asian-inspired motifs, Maria Theresa sought to establish a new aesthetic. She solicited Liotard's help, sending him to the imperial porcelain factory to aid in the development of enamel colours. In a letter to his wife from Vienna on 2 May 1778, Liotard wrote: 'On Monday I must go to the porcelain manufactory with my son to see if I can be of use to this producer[;] they make beautiful things there but perhaps it could be improved.'[8] According to his son, the artist spent 'a lot of time in speaking with them thinking to give them instructions ... he gave them colour exercises to do, which I am not sure will succeed.'[9] Liotard appears to have briefly contemplated going into the porcelain business, making plaques to be painted and even going so far as to have a meeting with Count Leopold Kolowrat (1727–1809), then one of the most powerful economic ministers at the Habsburg court, who oversaw, among other duties, the state-owned manufactories.[10] The artist's experimental enamel paintings on glass were probably what captured Maria Theresa's attention. He created 'transparent paintings', bringing a selection with him to Vienna to show the court.[11] In *Old Woman Asleep by a Fire*, a copy of a Dutch painting in the artist's collection from 1760, the luminous effects of the transparent support are evident in the rich blue colour of the woman's skirt and the cloth on the table (fig. 64). The vibrant, translucent hues would have been of great interest to the porcelain manufactory, which sought out recipes for distinctive enamel colours, which were equally as important as the porcelain body itself. Saucers known as *nuanciers* in French (*Farbenprobteller* in German) were repurposed in order to display the full range of enamel colours that a manufactory could make, as seen on a beautiful example by Frankenthal (fig. 65).

Liotard decided to write his treatise on painting in 1781, partly in response to his entrepreneurial failures, since no further records appear to have survived concerning his porcelain plaques or his recipes for enamels. In 1779, the artist's son had written to his mother, asking her to encourage his father to write down the 'secrets that he found on the manner of making pastels of solid colours. His beautiful glass, porcelain, and several other articles where he has made useful discoveries.'[12] Rather than write about his entrepreneurial endeavours, Liotard chose to focus on the fine art of painting in *Traité des principes et des règles de la peinture*, although scholars have noted his idiosyncratic approach to painting

Fig. 63
Tea service for two people (*tête-à-tête*), with a bouquet and foliate scrolls, about 1775–8
Vienna Imperial Porcelain Manufactory
Porcelain in a leather travel case, 35.5 × 37.5 × 45 cm (open)
Rijksmuseum, Amsterdam

Fig.64
Old Woman Asleep by a Fire,
1760
Painted enamel on glass,
44.5 × 34.8 cm
Kunsthistorisches Museum,
Vienna

Fig. 65
Trial plate, Frankenthal Porcelain
Factory, Germany, about 1775
Hard-paste porcelain, enamel
and gilding, 3.2 × 24.7 cm
The Fitzwilliam Museum,
Cambridge

compared to contemporary theories of the time. It is here that we find once again *The Lavergne Family Breakfast*, and the subject of porcelain:

> In my painting cabinet in Geneva, I have a painting of my own composition; it represents a woman who has before her a porcelain service, and is giving a cup of coffee to her daughter; there are thicknesses of colour, without being *highlights*, on the cups, on the pot & on the coffeepot, in order to better express the sheen of these forms, & to make them stand out better; also I dare to flatter myself that in this painting, the different objects have as much relief, volume and vigour as painting is able to give them.[13]

Of particular interest is the attention Liotard pays not to the depiction of the sitters, but to the objects. Initially, this is surprising since, as a pastellist, he was praised for his ability to render the subtle, lifelike effects of skin. However, even contemporary admirers of the artist were struck by the unusual ways in which he depicted human subjects in the manner of inanimate still-life objects. Count Francesco Algarotti (1712–1764), who purchased *The Chocolate Girl* from Liotard, wrote that it 'represents nature in bright light entirely without affectation and, although it is a European painting, it would be highly regarded even by the Chinese, who are sworn enemies of any kind of shadow'.[14] Viewers such as Algarotti associated the visual effects of Liotard's works, particularly the absence of shadow and uniform lighting, with a 'Chinese' aesthetic that lacked shadows. This is why French critics cast aspersions on Liotard's work, seeing it as flat, dull and lifeless, outcomes that were diametrically opposed to the ability of pastel to capture the vivid effects of living flesh in the round. The Abbé Le Blanc (1707–1781) famously described a pastel portrait by Liotard as 'flat, flat, flat, three times flat, and flatter than anything that has ever existed'.[15]

Building on Algarotti's comments about the Chinese aesthetic of Liotard's work, it might be possible to conjecture that this was a deliberate attempt to imitate the glossy, translucent effects of porcelain. Outside of the French academy, which Liotard had unsuccessfully attempted to join, luxury merchants in Paris prized the luminous qualities of Chinese porcelain, particularly when the smooth, mirror-like surfaces of the glazes were combined with French gilt-bronze mounts. As Kristel Smentek writes, French critics of the time used the expression *tacte flou* to describe the particular sensations elicited by Chinese porcelain. A somewhat ineffable term, *tacte flou* evoked both the smooth tactility of the porcelain body and the flowing, pleasing qualities of the lustrous glaze.[16] Given the degree to which Liotard carefully studied the objects that found their way into his compositions, it is not difficult to imagine him becoming immersed in studying the light-reflecting qualities of the porcelain body. Reflective surfaces are a recurrent motif in his work, from *The Chocolate Girl* (about 1744; see fig. 58) and *The Breakfast* (about 1752; fig. 66) to his late *Still Life: Tea Set* (about 1781–3; see fig. 51), which depicts an overturned tea set that has been haphazardly placed on a tray. Painted decades after *The Lavergne Family Breakfast*, the later

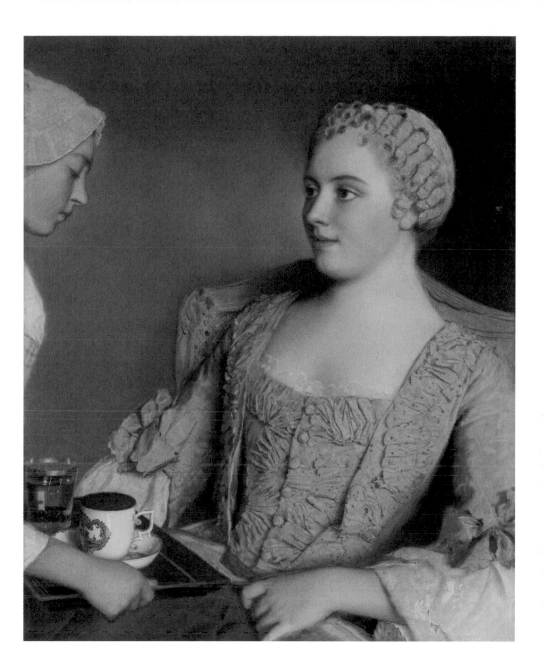

Fig. 66
The Breakfast, about 1752
Pastel on parchment,
67.3 × 54 cm
Bayerische
Staatsgemäldesammlungen –
Alte Pinakothek, Munich

work might in some ways be seen as the bookend to the artist's interest in porcelain. Here, the human users of the set have been replaced with the Chinese figures who enliven the surface of the teapot, teacups, saucers, slop bowl and milk jug, perhaps a commentary on the artist's ability to endow the inanimate with a sense of life.

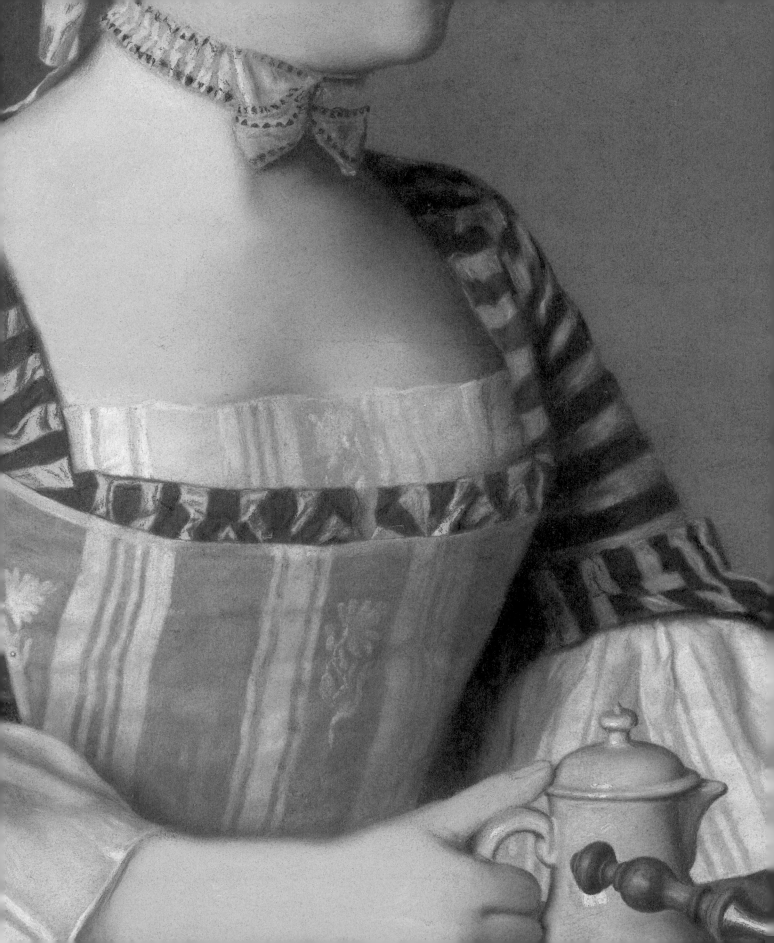

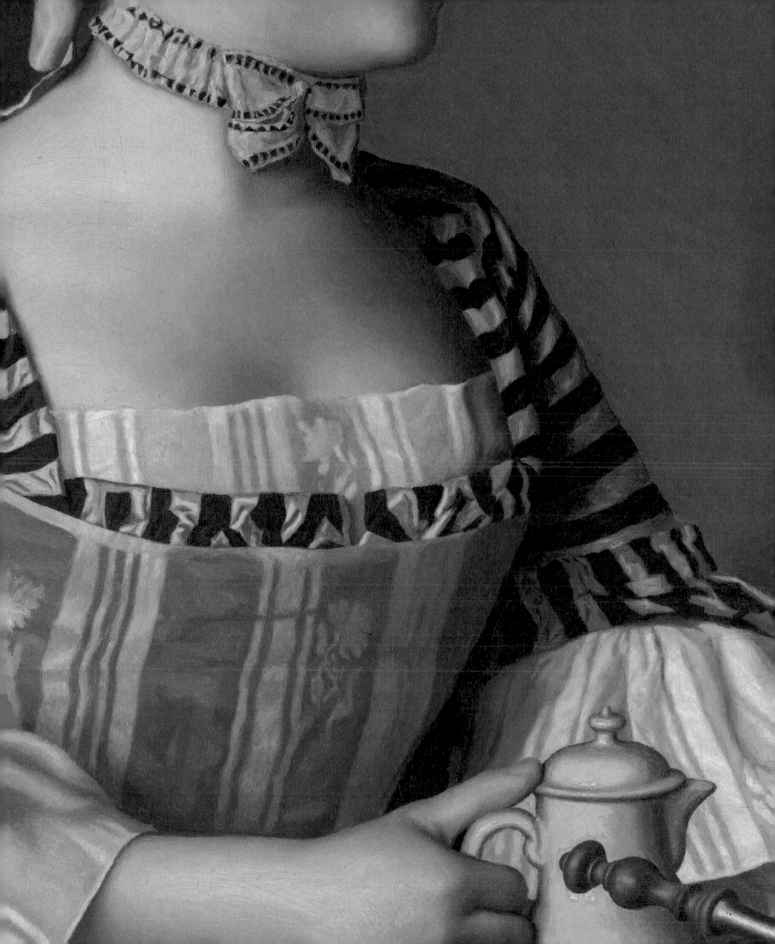

NOTES

All translations from the French are the authors' own.

1. The Many Faces of Jean-Etienne Liotard

1 Prolific in his work, Liotard was also, luckily for us, prolific in his writing. In addition to extensive correspondence and a published treatise mandating his rules of painting, he left two manuscript autobiographies, one written in 1760 and the other adapted by his eldest son around 1774. Conserved in the Musée d'art et d'histoire in Geneva, both are reproduced by Marcel Roethlisberger and Renée Loche in their monumental *catalogue raisonné* of the artist and are quoted here with these page numbers. For this reference to his beard, see the 'Autobiographie de Liotard de 1760' in Roethlisberger and Loche 2008, vol. 1, p. 62.

2 I am grateful to Neil Jeffares for pointing out the paradox of this picture. Although the chalk Liotard holds is blue and appears to be a pastel, the fact that he is using a *porte-crayon* suggests that he is working on the underdrawing of a portrait he is about to begin. Pastellists did not use *porte-crayons* when painting, as their work required too many changes of crayons. For more on the material of pastel and the technique of painting in it, see Chapter 2.

3 See Roethlisberger and Loche 2008, vol. 1, pp. 37–9.

4 See Williams 2012, pp. 1–2.

5 Many art historians have written about Liotard's self portraits, but I am particularly indebted to Hannah Williams for complicating and challenging the notion that these pictures were purely acts of self-promotion (see Williams 2012).

6 See Roethlisberger and Loche 2008, vol. 1, cat. nos 16, 17, 18 and 36.

7 'Autobiographie de 1760', p. 60; 'Autobiographie de 1774', p. 63.

8 'Autobiographie de 1774', p. 63.

9 Ibid.

10 Ibid., pp. 63, 67–8, 69.

11 For a history of the Académie Royale through its members' friendships with and portraits of each other, see Williams 2015.

12 See Jeffares 2015–16, in particular p. 30.

13 'Autobiographie de 1774', p. 64.

14 A photograph survives of Liotard's lost submission, *Achimeleth giving David Goliath's Sword* (Roethlisberger and Loche 2008, vol. 1, cat. no. 31). The records of the Académie Royale are rather biting, noting that 'the Company did not judge any painting worthy of first prize'. See De Chennevières and de Montaiglon 1851–60, vol. 5, p. 107.

15 See Roethlisberger and Loche 2008, vol. 1, pp. 251–60, especially cat. nos 32, 33, 34 and 35.

16 For a broad introduction to and richly illustrated account of the Grand Tour, see London and Rome 1996–7.

17 The description on *Portrait of Signora Maroudia Stay in Summer Attire, Milo* notes: 'the lace apron / the gold necklaces / the red stockings embroidered in / gold, the shoes embroidered in / silver / the edge of the petticoat / red / pink ribbons / what envelops the / head is a veil / the bottom is in lace'.

18 In addition to Roethlisberger and Loche 2008, Anne de Herdt's catalogue remains the most valuable resource for Liotard's drawings (see Geneva and Paris 1992).

19 John Montagu, 4th Earl of Sandwich, quoted in Sandwich and Cooke 1799, p. iii.

20 For more on this conundrum, see Roethlisberger and Loche 2008, vol. 1, p. 261.

21 See Whitlum-Cooper 2011, in particular pp. 75–87.

22 See Chapter 3, p. 54 and fig. 35.

23 For a comprehensive introduction to *turquerie* across the eighteenth century, see Williams 2014. Interestingly, Williams specifically discounts Liotard's works from the category of *turquerie*, which he defines as a European fantasy. Liotard, he counters, painted real Turkish subjects, not his own inventions (see pp. 63, 58–9).

24 Fehlmann 2015–16, pp. 67–8.

25 See Kaiser 2000, p. 16; Müge Göçek 1987, p. 3.

26 Lady Mary Wortley Montagu's accounts of her travels through the Ottoman Empire in 1716–18, for example, were widely circulated during her lifetime and were a major source of fascination with the region. For more about Grand Tour itineraries, see London and Rome 1996–7.

27 For more on Liotard and *turquerie*, see Smentek 2010 and Lajer-Burcharth 2003.

28 'Autobiographie de 1774', p. 67.

29 It should be remembered, however, that for all the care we now devote to the preservation and transport of pastels, works in this medium circulated much more freely in the eighteenth century. Works by the Venetian pastellist Rosalba Carriera (1673–1757) are a prime example, either being brought home by Grand Tourists from her studio in Venice or sent out across Europe by Carriera herself to her extensive network of correspondents. Liotard records no qualms about transporting *The Lavergne Family Breakfast* from Lyon to London.

30 De Chennevières and de Montaiglon 1851–60, vol. 5, p. 381.

31 Muralt 1725, p. 3.

32 Horace Walpole to Henry Seymour Conway, 5 May 1753, in Walpole 1937–83, vol. 37, p. 355.

33 See Hilles 1936, p. 18.

34 Roethlisberger and Loche 2008, vol. 1, p. 471.

35 Fanti 1767, p. 138; Moücke 1752–62, p. 276.

36 Liotard 1781, p. 4.

2. 'Precious Dust': The Rise of Pastel in Eighteenth-Century Europe

1 La Font de Saint-Yenne 1747, pp. 118–19.

2 Sani 1985, vol. 1, p. 390.

3 The largest pastel in the eighteenth century was painted by Joseph Vivien (1657–1734): *Max Emanuel before the Town of Mons* (1706) and measures 215 × 146 cm (Residenz, Munich).

4 Woermann 1887, pp. 759–86.

5 The online *Dictionary of Pastellists before 1800* (www.pastellists. com) is the most valuable and up-to-date resource for those interested in any aspect of pastel in the eighteenth century. For facts and figures, see 'Demographic analysis': http://pastellists.com/ Demographics.html (accessed January 2023).

6 Burns 2007, p. 1.

7 'Pastel', *n.2 and adj.*, *Oxford English Dictionary*.

8 We know glazing pastels was possible in the seventeenth century, as Joseph Vivien was received into the Académie Royale de Peinture et de Sculpture in 1698 as a 'Painter of portraits in pastel', and his works would have degraded rapidly without glazing: De Montaiglon 1875–1909, vol. 3, p. 236.

9 For more about Loriot and the development of fixatives, see Jeffares 2014.

10 Rosalba Carriera to Giovambattista Casotti, 26 April 1718, in Sani 1985, vol. 1, pp. 329–30.

11 For an overview on Stoupan, see Jeffares, http://pastellists.com/ Articles/STOUPAN.pdf (accessed January 2023).

12 John Singleton Copley to Jean-Etienne Liotard, 30 September 1762, in Jones 1914, p. 148.

13 Burns 2007, p. 17.

14 See Bordeaux 1984, pp. 61–8, and Ducamp 2001.

15 Shelley 2011, p. 11.

16 See Chapter 1, p. 25, for Joshua Reynolds's outrage at Liotard's prices in London.

17 See Russell 1772; Pernety 1757; Chaperon 1788; Bowles 1797.

18 Boutet 1709, pp. 167–78; Chaperon 1788, p. 26.

19 See Roethlisberger and Loche 2008, vol. 1, pp. 112–13.

20 Wine 2018, p. 341.

21 Ibid.

22 Jeffares, http://pastellists.com/ Misc/Prolegomena.pdf, p. 29 (accessed January 2023).

23 Claude-Henri Watelet, under 'PASTEL, peinture au (*Peinture mod.*)', in Diderot and d'Alembert 1751–72, vol. 12, p. 154.

24 Pernety 1757, p. 445.

25 Denis Diderot in Seznec and Adhémar 1957–67, vol. 3, p. 128.

26 Le Blanc 1747, p. 90.

27 Chaperon 1788, p. 9.

28 Joshua Reynolds, in Northcote 1818, vol. 1, p. 60.

29 Pernety 1757, p. 443.

30 See Jeffares 2015–16, in particular p. 31.

31 Her left hand holds a mahlstick, designed for use with oil and pastel so that an artist could rest their right forearm at a safe distance from the painted surface.

32 This document is preserved in the Generallandesarchiv Karlsruhe FA 5 A Corr 96, 35, and can be viewed online: https://www.karoline-luise.la-bw.de/bild_zoom/zoom. php?id=7983&obj_art=dokument& ausgangspunkt=suche& screenbreite=1536 &screenhoehe=824 (accessed January 2023). The document has been transcribed by Neil Jeffares (http://pastellists.com/Misc/ Treatises.pdf, pp. 21–2 [accessed January 2023]) and translated by Roethlisberger and Loche 2008, vol. 1, pp. 110–11.

33 See Roethlisberger and Loche 2008, vol. 1, pp. 110–11.
34 Ibid.

3. *The Lavergne Family Breakfast*

1 The only other instance we know of Liotard making a second version of a picture directly after the original after such a number of years is his portrait of Suzanne Curchod, later Madame Necker (Schönbrunn Palace, Vienna). Painted in Geneva in 1761, this beguiling pastel was sold to the Empress Maria Theresa during Liotard's second visit to Vienna in 1762. Returning to Vienna for a third time in 1777–8, he made a copy of the picture for himself (now lost). See Jeffares, http://www.pastellists.com/Essays/Liotardiana.pdf (accessed January 2023).
2 Roethlisberger and Loche 2008, vol. 1, p. 62; Liotard 1781, pp. 48–9, 57–8.
3 For a summary of contemporary biographies of Liotard, see Roethlisberger and Loche 2008, vol. 1, pp. 71–92.
4 Walpole 1786, vol. 4, p. 194; Roethlisberger and Loche 2008, vol. 1, cat. no. 299, p. 465.
5 We know Liotard's address from various notices he placed advertising the exhibition of his works (see the *Public Advertiser*, 21 November 1753 and 11 January 1754). In 2015, Neil Jeffares identified Liotard as the 'Turkish Gentleman, lately arrived here, who is very eminent in Portrait Painting … and remarkable by his Beard being long, curiously sharped and curled' (see Jeffares 2015–16).
6 Joshua Reynolds, in Northcote 1818, vol. 1, p. 60.
7 See Roethlisberger and Loche 2008, vol. 1, cat. no. 284, pp. 454–5.
8 The *Public Advertiser*, 11 January 1754, p. 2.
9 Neil Jeffares writes an excellent essay about this portrait and its precedent, *Lady Hawke* (1753), underlining the popularity of the format: http://www.pastellists.com/Essays/Liotard_Somerset_Hawke.pdf (accessed January 2023).
10 Roethlisberger and Loche 2008, vol. 1, pp. 431–8.
11 The *Public Advertiser*, 13 March 1755.
12 'Conversation', n.10, *Oxford English Dictionary*.

13 'Autobiographie de 1760', p. 62; Liotard 1781, p. 48.
14 For a full genealogy of the Lavergne family, see http://www.pastellists.com/Essays/Liotard_Dejeuner_Lavergne.pdf, p. 11 (accessed January 2023).
15 I am indebted to Neil Jeffares's ongoing and comprehensive investigations into the genealogical records, which have set straight many confusions in previous scholarship.
16 Jean-Jacques Juventin to his uncle, 22 October 1764, transcribed and published by Neil Jeffares, http://www.pastellists.com/Essays/Liotard_Dejeuner_Lavergne.pdf, p. 14 (accessed January 2023).
17 I am very grateful to Francis Russell for sharing his thoughts on Liotard's reuse of this composition with me and facilitating visits to some of these works. See Roethlisberger and Loche 2008, vol. 1, cat. nos 159, 160, 292, 293, 294.
18 *The Lavergne Family Breakfast* is one of a number of large pastels painted by Liotard over the course of his career. It measures 80 × 106 cm, while *L'Ecriture* (1752) measures 81 × 107 cm and *Suzanne Curchod* (1761) measures 85.5 × 104.7 cm. The largest portrait – astonishingly painted on a single piece of parchment – is that of *Madame de Vermenoux* (1764), measuring 120 × 95 cm. With thanks to Neil Jeffares.
19 I am grateful to my colleagues in the National Gallery's Scientific and Conservation departments for sharing their findings with me: Marika Spring, Catherine Higgitt, Lynne Harrison and especially Rachel Billinge, who talked me through the IRR so thoroughly.
20 Liotard 1781, p. 49.
21 Ibid.
22 Paris 2015, p. 12.
23 Following his departure from London in 1755, Liotard settled in the Low Countries, where he acquired a number of seventeenth-century Dutch paintings. For Liotard as a collector, see Roethlisberger and Loche 2008, vol. 1, pp. 120–3.
24 See Munich 2004.
25 The identification of these pieces of porcelain would not have been possible without conversations with many colleagues in the decorative arts who have shared their knowledge so generously, especially Mia Jackson, Patricia

Ferguson, Denise Campbell, Errol Manners and Julia Weber.
26 For an in-depth look at Imari, see Nagatake 2003 and Schiffer 2000.
27 Ferguson 2016.
28 Weber 2018.
29 See Dresden 2018.
30 This is *The Breakfast*, now in the Alte Pinakothek, Munich, which was owned until 1786 by the 2nd Earl of Harrington.
31 For a close study of this work, see Lippincott 1985.
32 Jeffares, http://www.pastellists.com/Essays/Liotard_Dejeuner_Lavergne.pdf, p. 7 (accessed February 2023).
33 Paris 2015, p. 44.
34 See Roethlisberger and Loche 2008, vol. 1, pp. 71–91.
35 See Chapter 2, p. 40.
36 Christie's, London, 15 April 1774, lot 76.
37 Roethlisberger and Loche 2008, vol. 1, no. 495, pp. 620–2.
38 Jean-Baptiste Pierre (1713–1789), first painter to the King, called Liotard a charlatan. See Roethlisberger and Loche 2008, vol. 1, pp. 128–9.
39 Jean-Etienne Liotard to his wife, 10 December 1777, reprinted in Roethlisberger and Loche 2008, vol. 2, pp. 745–6.

4. Of Pastels and Porcelain

1 For the history of porcelain and Dutch and Chinese exchange, see Van Campen, Diercks and Corrigan 2015.
2 See Smentek 2010.
3 See Drexler 2018; You 2016.
4 Drexler 2018, p. 123.
5 I am grateful to Francesca Whitlum-Cooper for sharing information on the cup. My special thanks to Patricia Ferguson for discussing the Japanese porcelain with me.
6 On the taste for Japanese export porcelain in the eighteenth century, see Ayers, Impey and Mallet 1990.
7 Inventaire après décès, 1789, 1791, Geneva, Archives d'Etat, Jur. Civ. F. n°812. Summarised in Roethlisberger and Loche 2008, vol. 2, p. 58: '50 draps, 40 douzaines de serviettes, 50 nappes, 8 douzaines d'essuie-mains', 'Beaucoup de porcelaines'.
8 Roethlisberger and Loche 2008, vol. 1, p. 103.
9 Quoted in Swoboda and Oberthaler 2012, p. 17, n. 3.

10 I am grateful to Claudia Lehner-Jobst for her help on Kolowrat and the Vienna Imperial Manufactory.
11 Lippincott 1985, p. 122.
12 Jean-Etienne Liotard *fils* to his mother, quoted in Roethlisberger and Loche 2008, vol. 2, p. 103.
13 Liotard 1781, pp. 95–6.
14 Enke 2018, pp. 47–8.
15 Jeffares 2006 and online, p. 5.
16 Smentek 2015, p. 49.

BIBLIOGRAPHY

'Autobiographie de 1760'
'Autobiographie de Liotard de 1760', in Roethlisberger and Loche 2008, vol. 1, pp. 59–62

'Autobiographie de 1774'
'Autobiographie de Liotard de 1774', in Roethlisberger and Loche 2008, vol. 1, pp. 62–70

Ayers, Impey and Mallet 1990
J. Ayers, O. Impey and J.V.G. Mallet (eds), *Porcelain for Palaces: The Fashion for Japan in Europe, 1650–1750*, London 1990

Bordeaux 1984
J.L. Bordeaux, *François Le Moyne and his Generation, 1688–1737*, Neuilly-sur-Seine 1984

Boutet 1709
C. Boutet, *Traité de la peinture en mignature*, with anonymous supplement *Traité de la peinture au pastel*, The Hague 1709

Bowles 1797
C. Bowles, *The Art of Painting in Water Colours: Exemplified in landscapes, flowers, &c. Together with instructions for painting on glass and in crayons*, tenth edn, London 1797

Burns 2007
T. Burns, *The Invention of Pastel Painting*, London 2007

Chaperon 1788
P.R. de C [Paul-Romain Chaperon], *Traité de la peinture au pastel*, Paris 1788

De Chennevières and de Montaiglon 1851–60
P. de Chennevières and A. de Montaiglon (eds), *Abécédario de P.J. Mariette et autres notes inédites de cet amateur sur les arts et les artistes*, 6 vols, Paris 1851–60

De Montaiglon 1875–1909
A. de Montaiglon, *Procès-Verbaux de l'Académie Royale de Peinture et de Sculpture 1648–1793*, 11 vols, Paris 1875–1909

Diderot and d'Alembert 1751–72
D. Diderot and J.L.R. d'Alembert (eds), *Encyclopédie ou Dictionnaire raisonné des sciences, des arts et des métiers, par une Société de Gens de lettres*, 28 vols, Paris 1751–72

Dresden 2018
R. Enke et al., *'The Most Beautiful Pastel Ever Seen': The Chocolate Girl by Jean-Etienne Liotard*, exh. cat., Staatliche Kunstsammlungen Dresden, Munich 2018

Drexler 2018
S. Drexler, 'Chocolate, Tea, Coffee: A Brief History of the Europeanization of Three Exotic Hot Beverages', in Dresden 2018, pp. 120–9

Ducamp 2001
E. Ducamp, *L'apothéose d'Hercule de François Lemoyne au château de Versailles: Histoire et restauration d'un chef-d'œuvre*, Paris 2001

Edinburgh and London 2015–16
M. Stevens, C. Baker et al., *Jean-Etienne Liotard*, exh. cat., Scottish National Gallery, Edinburgh; Royal Academy of Arts, London, London 2015–16

Enke 2018
R. Enke, 'From "Stoubmenche" to *Chocolate Girl*: On Jean-Etienne Liotard's Iconic Pastel Painting in Dresden's Gemäldegalerie', in Dresden 2018, pp. 40–57

Etienne and Lee 2020–21
N. Etienne and C. Lee, 'Lüster, Lack und Liotard: Techniken und Texturen zwischen Asien und Europa', in N. Etienne, C. Brizon, C. Lee and E. Wismer (eds), *Exotic Switzerland? Looking Outward in the Age of Enlightenment*, exh. cat., Palais de Rumine, Lausanne, Zurich 2020–21, pp. 4–11

Fanti 1767
V. Fanti, *Descrizzione completa di tutto ciò che ritrovasi nella Galleria di pittura e scultura di Sua Altezza Giuseppe Wenceslao ... di Lichtenstein*, Vienna 1767

Fehlmann 2015–16
M. Fehlmann, 'Orientalism', in Edinburgh and London 2015–16, pp. 65–71

Ferguson 2016
P.F. Ferguson, '"Japan China" Taste and Elite Ceramic Consumption in 18th-Century England: Revising the Narrative', in J. Stobart and A. Hann (eds), *The Country House: Material Culture and Consumption*, Swindon 2016, pp. 113–22

Geneva and Paris 1992
A. de Herdt, *Dessins de Liotard: suivi du catalogue de l'œuvre dessiné*, exh. cat., Musée d'art et d'histoire, Geneva; Musée du Louvre, Paris, Geneva and Paris 1992

Hilles 1936
F.W. Hilles, *The Literary Career of Sir Joshua Reynolds*, Cambridge 1936

Jeffares 2006 and online
N. Jeffares, *The Dictionary of Pastellists before 1800*, London 2006 and online: http://www.pastellists.com/

Jeffares 2014
N. Jeffares, 'Loriot, Pellechet, Jurine: The Secrets of Pastel', *Pastel & Pastellists*: http://www.pastellists.com/Essays/Loriot.pdf

Jeffares 2015–16
N. Jeffares, 'Liotard and the Medium of Pastel', in Edinburgh and London 2015–16, pp. 27–33

Jones 1914
G. Jones (ed.), *Letters and Papers of John Singleton Copley and Henry Pelham, 1739–1776*, Boston 1914

Kaiser 2000
T. Kaiser, 'The Evil Empire? The Debate on Turkish Despotism in Eighteenth-Century French Political Culture', *The Journal of Modern History*, 72, no. 1 (2000), pp. 6–34

La Font de Saint-Yenne 1747
E. La Font de Saint-Yenne, *Réflexions sur quelques causes de l'état présent de la peinture en France avec un examen des principaux ouvrages exposés au Louvre, le mois d'août 1746*, The Hague 1747

Lajer-Burcharth 2003
E. Lajer-Burcharth, 'Jean-Etienne Liotard's Envelopes of Self', in J. Ryan and A. Thomas (eds), *Cultures of Forgery: Making Nations, Making Selves*, New York and London 2003, pp. 127–44

Le Blanc 1747
J.B. Le Blanc, *Lettre sur l'exposition des ouvrages de peinture, sculpture, etc. de l'année 1747*, Paris 1747

Liotard 1781
J.E. Liotard, *Traité des principes et des règles de la peinture*, Geneva 1781

Lippincott 1985
L. Lippincott, 'Liotard's "China Painting"', *The J. Paul Getty Museum Journal*, 13 (1985), pp. 121–30

London and Rome 1996–7
A. Wilton and I. Bignamini (eds), *The Grand Tour: The Lure of Italy in the Eighteenth Century*, exh. cat., Tate Gallery, London; Palazzo delle Esposizioni, Rome, London 1996–7

Moücke 1752–62
F. Moücke, 'Museo fiorentino', in *Serie di ritratti degli eccellenti pittori dipinti di propria mano che esistono nell' Imperial Galleria di Firenze colle vite in compendio de' medesimi descritte da Francesco Moücke – Museo fiorentino che contiene i ritratti de' pittori*, 4 vols, Florence 1752–62

Müge Göçek 1987
F. Müge Göçek, *East Encounters West: France and the Ottoman Empire in the Eighteenth Century*, Oxford 1987

Munich 2004
M. Kopplin and M.S. van Aken-Fehmers (eds), *Schwartz Porcelain: The Lacquer Craze and its Impact on European Porcelain*, exh. cat., Museum für Lackkunst, Münster; Schloss Favorite, Rastatt, Munich 2004

Muralt 1725
B.L. de Muralt, *Lettres sur les Anglois et les François et sur les voiages*, [London?] 1725

Nagatake 2003
T. Nagatake, *Classic Japanese Porcelain: Imari and Kakiemon*, Tokyo 2003

New York 2011
K. Baetjer and M. Shelley (eds), *Pastel Portraits: Images of Eighteenth-Century Europe*, exh. cat., Metropolitan Museum of Art, New York, adapted from *The Metropolitan Museum of Art Bulletin*, 68, no. 4 (Spring 2011)

Northcote 1818
J. Northcote, *The Life of Sir Joshua Reynolds, LL. D., F.R.S., F.S.A. &c., Late President of the Royal Academy: Comprising Original Anecdotes of Many Distinguished Persons, his Contemporaries: and a Brief Analysis of his Discourses*, 2 vols, London 1818

Paris 2015
R.M. Herda-Mousseaux et al., *Thé, café ou chocolat? Les boissons exotiques à Paris au XVIIIe siècle*, exh. cat., Musée Cognacq-Jay, Paris 2015

Perez 1997
M.F. Perez, 'Liotard et Lyon,' in Perez, *Genava*, vol. 45, [location unknown] 1997, pp. 35–40

Pernety 1757
A.J. Pernety, *Dictionnaire portatif de peinture, sculpture et gravure*, Paris 1757

Roethlisberger and Loche 2008
M. Roethlisberger and R. Loche, *Liotard: Catalogue, sources et correspondance*, 2 vols, Doornspijk 2008

Russell 1772
J. Russell, *Elements of Painting with Crayons*, London 1772

Sandwich and Cooke 1799
J. Montagu [4th Earl of Sandwich] and J. Cooke, *A Voyage Performed by the Late Earl of Sandwich round the Mediterranean in the years 1738 and 1739*, London 1799

Sani 1985
B. Sani, *Rosalba Carriera: Lettere, diari, frammenti*, 2 vols, Florence 1985

Schiffer 2000
N. Schiffer, *Imari, Satsuma, and Other Japanese Export Ceramics*, revised and expanded second edn, Atglen 2000

Seznec and Adhémar 1957–67
J. Seznec and J. Adhémar, *Diderot: Salons*, 4 vols, Oxford 1957–67

Shelley 2011
M. Shelley, 'Painting in the Dry Manner: The Flourishing of Pastel in 18th-Century Europe', in New York 2011, pp. 5–56

Smentek 2010
K. Smentek, 'Looking East: Jean-Etienne Liotard, the Turkish Painter', *Ars Orientalis*, 39 (2010), pp. 84–112

Smentek 2015
K. Smentek, 'Global Circulations, Local Transformations: Objects and Cultural Encounter in the Eighteenth Century', in P. ten-Doesschate Chu and N. Ding (eds), *Qing Encounters: Artistic Exchanges between China and the West*, Los Angeles 2015, pp. 43–55

Swoboda and Oberthaler 2012
G. Swoboda and E. Oberthaler, *Enamel versus Pastel: Jean-Etienne Liotard (1702–1789), Painter of Extremes*, Vienna 2012

Van Campen, Diercks and Corrigan 2015
J. van Campen, F. Diercks and K. Corrigan (eds), *Asia in Amsterdam: The Culture of Luxury in the Golden Age*, Salem 2015

Walpole 1786
H. Walpole and G. Vertue, *Anecdotes of Painting in England: with some account of the principal artists; and incidental notes on other arts*, 4 vols, 1765–71: vol. 4, third edn, London 1786

Walpole 1937–83
H. Walpole, *The Yale Edition of Horace Walpole's Correspondence*, ed. W.S. Lewis, 48 vols, New Haven 1937–83

Weber 2018
J. Weber, 'What Struck Algarotti as Chinese in Liotard's *Chocolate Girl*', in Dresden 2018, pp. 68–75

Whitlum-Cooper 2011
F. Whitlum-Cooper, 'Drawing Distinctions: Jean-Etienne Liotard in Constantinople and Vienna', *Immediations*, 2, no. 4 (2011), pp. 75–96

Williams 2012
H. [Hannah] Williams, 'A Phenomenology of Vision: The Self-Portraits of Jean-Etienne Liotard', *RIHA Journal* (30 January 2012): http://www.riha-journal.org/articles/2012/2012-jan-mar/williams-phenomenology-of-vision

Williams 2014
H. [Haydn] Williams, *Turquerie: An Eighteenth-Century European Fantasy*, London 2014

Williams 2015
H. [Hannah] Williams, *Académie Royale: A History in Portraits*, Ashgate 2015

Wine 2018
H. Wine et al., *National Gallery Catalogues: The Eighteenth-Century French Paintings*, New Haven and London 2018

Woermann 1887
K. Woermann, *Katalog der Königlichen Gemäldegalerie zu Dresden*, Dresden 1007

You 2016
Y. You, *Coffee, Tea, and Chocolate: Consuming the World*, Detroit 2016

LIST OF EXHIBITED WORKS

Japanese Imari-ware cup and saucer,
about 1690–1720
Porcelain, cup: 4.5 × 7.8 cm;
saucer: 2.2 × 12.3 cm
Staatliche Kunstsammlungen Dresden,
Porzellansammlung
Inv.-Nr. PO 5039
Fig. 61

Jean-Etienne Liotard (1702–1789)
Portrait of Signora Marigot, Smyrna, 1738
Red and black chalk on paper,
21.5 × 13.5 cm
Musée du Louvre, département des Arts
graphiques, Paris
RF 1369, recto
Fig. 6

Jean-Etienne Liotard (1702–1789)
*Woman from Constantinople sitting
on a Divan*, 1738–42
Red and black chalk on paper,
25 × 20.5 cm
Musée du Louvre, département des Arts
graphiques, Paris
RF 1374, recto
Fig. 8

Jean-Etienne Liotard (1702–1789)
*Portrait of a Grand Vizir, or of a European
dressed as one*, about 1741
Pastel on parchment, 61.6 × 47.6 cm
The National Gallery, London
Presented by Mrs John P. Heseltine
in memory of her husband, 1929
NG4460
Fig. 25

Jean-Etienne Liotard (1702–1789)
The Chocolate Girl, about 1744
Brown ink on four sheets of paper,
83.8 × 58.5 cm
MAH Musée d'art et d'histoire, Ville
de Genève. Don de la Société auxiliaire
du Musée, 1934
1935-0008
Fig. 53

Jean-Etienne Liotard (1702–1789)
Three portraits of Liotard mounted on
a sheet from the collection of Horace
Walpole, about 1750–70
Etchings on paper, 40.2 × 21.5 cm
British Museum
1852,0214.357–9
Figs 5 and 12

Jean-Etienne Liotard (1702–1789)
A Self-Portrait, about 1753
Enamel, 5.9 × 4.5 cm
The Royal Collection /
HM King Charles III
RCIN 421436
Fig. 13

Jean-Etienne Liotard (1702–1789)
Sir Everard Fawkener, about 1753–5
Enamel on copper, 7.7 × 6.4 cm
The Ashmolean Museum, University
of Oxford. Presented by Miss Alice L.
Lascelles, 2001
WA2001.2
Fig. 34

Jean-Etienne Liotard (1702–1789)
Lady Fawkener, 1754
Pastel on vellum, 73.6 × 58.5 cm
Compton Verney, Warwickshire
CVCSC:0288.B
Fig. 35

Jean-Etienne Liotard (1702–1789)
The Lavergne Family Breakfast, 1754
Pastel on paper, mounted on canvas,
80 × 106 cm
The National Gallery, London
Accepted in lieu of Inheritance Tax
by HM Government from the estate
of George Pinto and allocated to the
National Gallery, 2019
NG6685
Fig. 1

Jean-Etienne Liotard (1702–1789)
*Portrait of Charlotte Boyle, Marchioness
of Hartington*, about 1754
Pastel on prepared paper, 58 × 48 cm
Trustees of the Chatsworth Settlement
Fig. 37

Jean-Etienne Liotard (1702–1789)
Portrait of Eva-Marie Garrick, about 1754
Pastel on paper, 62 × 47.5 cm
Trustees of the Chatsworth Settlement
Fig. 38

Jean-Etienne Liotard (1702–1789)
*Lady Anne Somerset, later Countess of
Northampton*, about 1755
Pastel on vellum, 61 × 47 cm
Trustees of the Chatsworth Settlement
Fig. 36

Jean-Etienne Liotard (1702–1789)
Dutch Girl at Breakfast, about 1756
Oil on canvas, 46.8 × 39 cm
Rijksmuseum. Purchase made possible
by the BankGiro Lottery, the Rembrandt
Association through its 'Nationaal Fonds
Kunstbezit', Mondriaan Fund, VSBfonds,
H. B. van der Ven, The Hague, Fonds
De Haseth-Möller/Rijksmuseum Fonds,
LOBA Fonds/Rijksmuseum Fonds, Nan
van Andel Fonds/Rijksmuseum Fonds,
Marjon Ornstein Fonds/Rijksmuseum
Fonds, Elles Nansink Fonds/
Rijksmuseum Fonds, Rijksmuseum
International Circle, gifts from bequests
and anonymous benefactors
SK-A-5039
Fig. 59

Jean-Etienne Liotard (1702–1789)
*George Keppel, Earl of Albemarle
(1724–1772)*, 1768
Pastel on paper, 65.4 × 53.3 cm
Private collection, London
Figs 39 and 40

Jean-Etienne Liotard (1702–1789)
The Lavergne Family Breakfast, 1773
Oil on canvas, 81.4 × 103 cm
Private collection, Waddesdon
Fig. 2

Jean-Etienne Liotard (1702–1789)
Self portrait proof, about 1778–80
Roulette and engraving over mezzotint,
48 × 40 cm
British Museum
1931,0413.518
Fig. 16

Jean-Etienne Liotard (1702–1789)
Still Life: Tea Set, about 1781–3
Oil on canvas mounted on board,
37.8 × 51.6 cm
The J. Paul Getty Museum, Los Angeles
84.PA.57
Fig. 51

Tea service (*tête-à-tête*) with a bouquet
and foliate scrolls, about 1775–8
Kaiserliche Porzellanmanufaktur
Porcelain in a leather travel case,
35.5 × 37.5 × 45 cm (open)
Rijksmuseum. Gift of L. Haase-
Scheltema, Amsterdam
BK-1960-35
Fig. 63

LIST OF LENDERS

Amsterdam
Rijksmuseum

Chatsworth
Trustees of the Chatsworth Settlement

Dresden
Staatliche Kunstsammlungen Dresden,
Porzellansammlung

Geneva
MAH Musée d'art et d'histoire,
Ville de Genève

London
The British Museum
His Majesty The King

Los Angeles
The J. Paul Getty Museum

Oxford
The Ashmolean Museum,
University of Oxford

Paris
Musée du Louvre

Private collections
London
Waddesdon

Warwickshire
Compton Verney House Charity

And those lenders who wish to
remain anonymous

ACKNOWLEDGEMENTS

An exhibition is truly a team effort, and one of the great pleasures of spending the last few years thinking about Liotard and *The Lavergne Family Breakfast* has been the generosity of colleagues: those who have shared their knowledge, those who have lent their artworks, and those who have dived into the kinds of conversations that have challenged and furthered my thinking.

The exhibition has been made possible by the generosity of its lenders: the Ashmolean Museum, the British Museum, Compton Verney House Charity; the J. Paul Getty Museum; Musée d'art et d'histoire, Ville de Genève; Musée du Louvre; Staatliche Kunstsammlungen Dresden, Porzellansammlung; Rijksmuseum; His Majesty The King; and the Trustees of the Chatsworth Settlement. The National Gallery is indebted to the directors and curators at these institutions: Laurence des Cars, Marie-Eve Celio, Hugo Chapman, Geraldine Collinge, Taco Dibbits, Femke Diercks, Bénédicte De Donker, Hartwig Fischer, Josephina de Fouw, Davide Gasparotto, Annelise Horne, Amy Orrock, Timothy Potts, Xavier Salmon, Sarah Vowles, Marc-Olivier Wahler, Julia Weber and Anne Woollett. For lending us masterpieces from their personal collections, we express deep gratitude to his Grace the Duke of Devonshire and to those lenders who wish to remain anonymous.

The world of Liotard studies may be small, but I have benefited enormously from those within it. For generous and fruitful conversations, I thank MaryAnne Stevens, Marjorie Shelley, Christopher Baker, Jonny Yarker and Perrin Stein. Special thanks are due to Francis Russell for being such an unwavering champion both of the National Gallery's pastel and of this project. In the field of decorative arts, I am extremely grateful to the many colleagues – and colleagues' colleagues – who offered advice and expertise on the porcelain depicted in *The Lavergne Family Breakfast*, especially my co-author Iris Moon, Mia Jackson, Patricia Ferguson, Denise Campbell, Errol Manners, Julia Weber and Ching-Ling Wang. For sharing their expertise, I thank Isabelle Roché and Margaret Zayer of the Maison du Pastel, and Jacques Brejoux of the Moulin du Verger. My thanks also to Adrian Sassoon, Naomi Richards, Alice Martin, Helen Loveday, Richard Mansell-Jones and a private collector from Waddesdon for their support.

At the National Gallery, I would like to thank Phoebe Newman, Sunnifa Hope, Giulia Segreto and Lucy Rutherford for their excellent management of the exhibition; and Catherine Hooper, Becca Thornton, Justine Montizon, Jane Hyne and the many others who have worked tirelessly to produce this beautiful catalogue. My understanding of *The Lavergne Family Breakfast* has benefited immeasurably from time spent looking at it with colleagues from our Conservation and Scientific departments, especially Larry Keith, Lynne Harrison, Catherine Higgitt, Rachel Billinge and Marika Spring. My thanks also to Gabriele Finaldi, Eleanor Richards, Jane Knowles, Sophie Clark, Alan Brooks, Joshua Page, Juraj Grac, Andrew Bruce, James Thompson, Nicola Smith, Louise Nyborg and Leah Kharibian. Justine Rinnooy Kan's boundless enthusiasm was invaluable. Any errors that have crept in are entirely my own.

Anyone undertaking the study of a work by Liotard owes a tremendous debt to the late Marcel Roethlisberger, whose passion for and deep knowledge of the artist set a fantastically high bar for the rest to follow. Finally, I wish to thank Neil Jeffares – the doyen of pastel studies – for his careful reading of an early draft of this catalogue, his phenomenally detailed scholarship and the generosity with which he shares it.

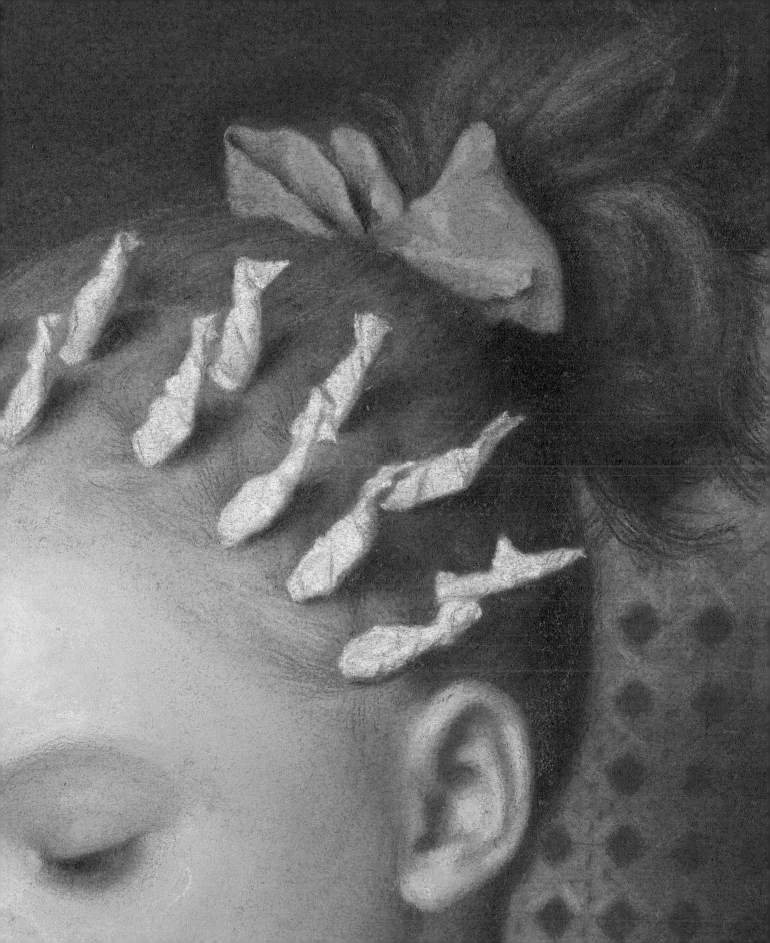

PHOTOGRAPHIC CREDITS

Amsterdam
© Rijksmuseum, Amsterdam: figs 44, 59, 63.

Cambridge
Image © The Fitzwilliam Museum, Cambridge: fig. 65.

La Chaux-de-Fonds
© Musée des beaux-arts La Chaux-de-Fonds, Collection René et Madeleine Junod. Photo: Pierre Bohrer, Le Locle: fig. 14.

Derbyshire
© Devonshire Collection, Chatsworth. Reproduced by permission of the Chatsworth Settlement Trustees: figs 36, 37, 38.

Dresden
© Gemäldegalerie Alte Meister, Staatliche Kunstsammlungen Dresden, photo: Wolfgang Kreische: fig. 58.
© Porzellansammlung, Staatliche Kunstsammlungen Dresden, photo: Adrian Sauer: fig. 61.

Florence
Galleria degli Uffizi, Florence © Photo Scala, Florence – courtesy of the Ministero Beni e Att. Culturali e del Turismo: figs 11, 19.

Geneva
© Musée d'art et d'histoire, Ville de Genève, photo: Bettina Jacot-Descombes: figs 4, 15, 17, 53.

Glasgow
© Hunterian Museum & Art Gallery / Bridgeman Images: fig. 50.

Karlsruhe
Staatliche Kunsthalle, Karlsruhe © Photo Scala, Florence / bpk, Bildagentur für Kunst, Kultur und Geschichte, Berlin. Photographer: Wolfgang Pankoke: fig. 30.

London
© British Library Board. All Rights Reserved / Bridgeman Images: fig. 43.
British Museum, London © The Trustees of the British Museum: figs 5, 12, 16, 22.
© The National Gallery, London: figs 1, 23, 25, 27, 28, 29, 46, 47, 49.
Royal Collection Trust / © His Majesty King Charles III 2023: figs 13, 41, 42.

Los Angeles
The J. Paul Getty Museum, Los Angeles © Image courtesy of Getty's Open Content Program: figs 20, 51.

Moulin du Verger
© Photograph by Penley Knipe: fig. 26.

Munich
Bayerische Staatsgemäldesammlungen – Alte Pinakothek München © Photo Scala, Florence / bpk, Bildagentur für Kunst, Kultur und Geschichte, Berlin: fig. 66.

Norwich
© Norfolk Museums Service (Norwich Castle Museum & Art Gallery): fig. 10.

Oxford
Image © Ashmolean Museum, University of Oxford: fig. 34.

Paris
Musée du Louvre, Paris. Photos © RMN-Grand Palais (musée du Louvre) / Michèle Bellot: figs 8, 9; Michel Urtado: fig. 7; Jean-Gilles Berizzi: figs 6, 60.
© Margaret Zayer / La Maison du Pastel: fig. 18.

Private Collections
© Courtesy the owner / photo: The National Gallery, London: fig. 2.
© Image courtesy of Lowell Libson & Jonny Yarker Ltd: figs 39, 40.

Saint Quentin
Musée Antoine Lecuyer © RMN-Grand Palais / Mathieu Rabeau: fig. 21.

Stanford
Adapted from a map in the David Rumsey Map Collection, David Rumsey Map Center, Stanford Libraries: fig. 3.

Stockholm
Nationalmuseum, Stockholm. Photo: Anna Danielsson / Nationalmuseum: fig. 24.

Vienna
Kunsthistorisches Museum © KHM-Museumsverband: fig. 64; © Heritage Images / Fine Art Images / akg-images: fig. 45.

Warwick
Compton Verney House Trust © Compton Verney, photography by Jamie Woodley: fig. 35.

Winterthur
Kunst Museum Winterthur, Stiftung Oskar Reinhart, Ankauf, 1950 © SIK-ISEA, Zürich, Jean-Pierre Kuhn: fig. 57.